THE GOLDEN AGE OF
FLOWERS

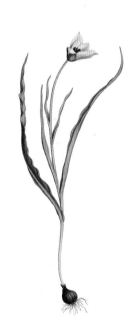

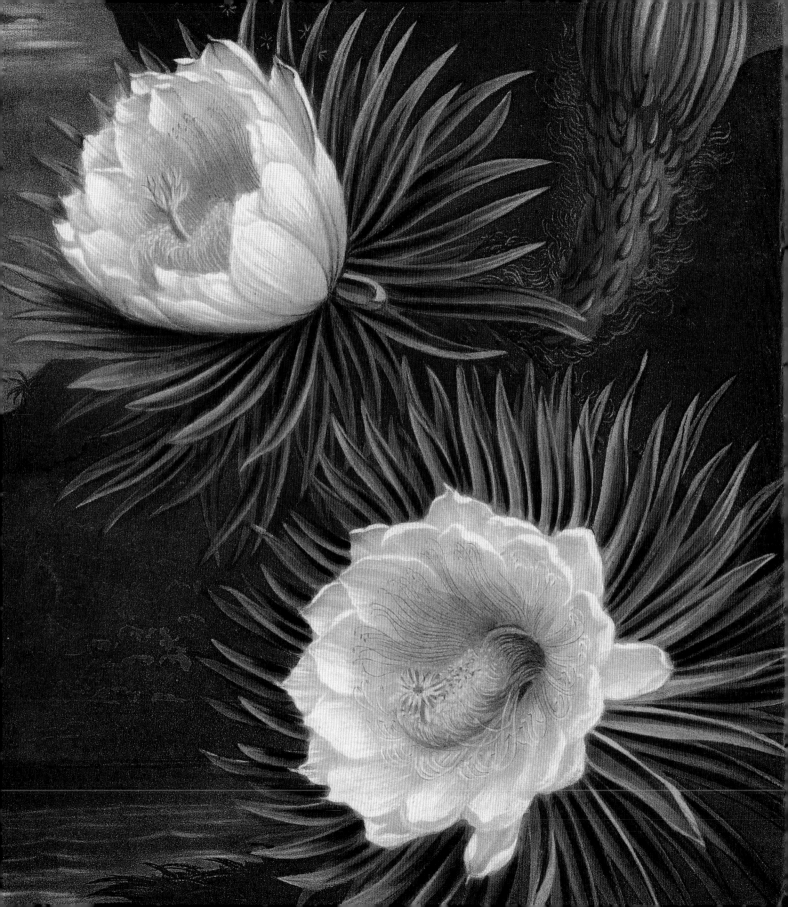

THE GOLDEN AGE OF
FLOWERS

BOTANICAL ILLUSTRATION IN
THE AGE OF DISCOVERY 1600-1800

CELIA FISHER

THE BRITISH LIBRARY

First published in 2011 by
The British Library
96 Euston Road
London NW1 2DB

This paperback edition published in 2013

British Library Cataloguing in
Publication Data
A catalogue record for this publication is
available from The British Library

ISBN 978 0 7123 5895 8

Designed and typeset by
Bobby & Co, London
Colour reproduction by
Dot Gradations Ltd, Essex
Printed in Hong Kong by
Great Wall Printing Co. Ltd

Frontispiece
Selenicereus from Robert John Thornton,
Temple of Flora, London, 1799–1807. 10.Tab.40.

Right
Passiflora alata from *The Botanical Magazine*,
W. Curtis, London, 1787–1801. 678.c.1,
Vols. 1–2, f.66.

Pages 22–23
Detail of rose from Pierre Joseph Redoute,
Les Roses, Paris, 1817–24. 450.h.22, f.61.

Author's note

The naming of plants has always been a challenge, and during the period covered by this book, when new plants were arriving from all points of the compass, confusion threatened to overwhelm even the cleverest scientists. Botanical plates often bore a string of descriptive Latin names; some were helpful like *Hyacinthus africanus tuberosus flore caeruleo umbellate inodorae*, for agapanthus; others were misleading like *Gladiolo aethiopico*, for babiana, which is not a gladiolus and comes from South Africa. Many of the older Latin names have been superseded, but Latin is still the universal language of botany and in this book, seeking simplicity, the plants have been arranged alphabetically by their one generic Latin name, which has often become the English name as well. Where a different English name is widely used this has been added; and just once a familiar Latin name, Encyclia, for the cockle-shell orchid, has been reluctantly abandoned for the new nomenclature Prosthechea. Many of the plants which were wonderfully new two or three hundred years ago are now familiar – but the adventures of the plant-hunters, the conundrums of the scientists, the dedication of the cultivators and the skills of the botanical illustrators should still be celebrated. The subject is huge, and this book touches on all aspects from biography to geography, hoping that readers, initially inspired by the beauty of the flowers, will be lured into further explorations of their own.

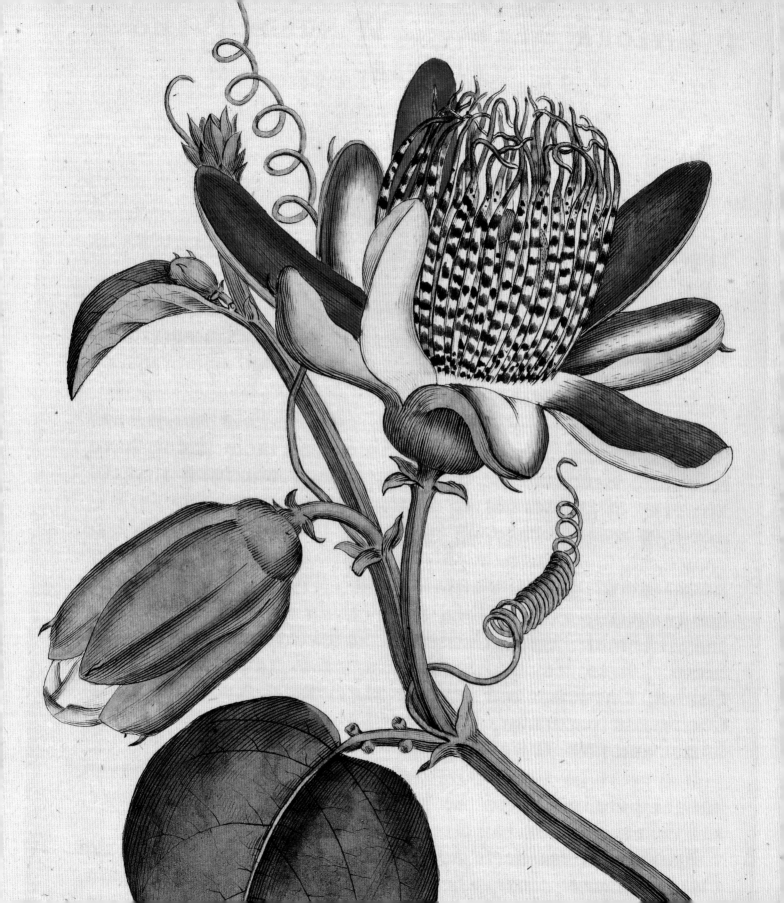

Contents

Introduction

THE STORY OF PLANTS is also the story of those who loved, collected and recorded them, and never was this such an intense process as in the eighteenth century. Calling this period of worldwide expansion a golden age ignores the danger and exploitation that lay at its heart, but botanically the term is apt – suggesting energy, wonder and a degree of innocence.

The key figure of the age was Carl Linnaeus (1707–78). When he became Professor of Botany at Uppsala University in Sweden in 1741 he had already published *Systema Natura*, proposing a new way of classifying plants by counting their male parts (the pollen-bearing stamens) and female parts (the pistils awaiting fertilization of the seeds). After overcoming opposition to this daring sexual system, Linnaeus also proposed his new way of naming plants: the binomial system. This distinguished plants by just two Latin names, first the genus (the wider group, like *Rosa*) and then the species (the smaller, identically related group, such as *Rosa gallica* or *R. damascena*). By the time Linnaeus published this in *Species Plantarum* in 1753 he had named and classified well over seven thousand plants, and the chaotic practice of tagging extra Latin names onto every newly discovered flower was in abeyance. This clarity was a great relief to everyone from professors to plant hunters, and Linnaeus became central to the whole network – inspiring his students to travel far and wide on his behalf, and cunningly asking every European botanist 'to send me any plants I have not yet described, complete with flowers'.

This botanical networking was not a new phenomenon. In the mid-sixteenth century Spanish botanists heralded the age of discovery with accounts of their expeditions to Mexico (including the first descriptions of dahlias and sunflowers), which inspired their Italian contemporary Ulisse Aldrovandi to wish he could travel there himself; although he was fully occupied as Professor at Bologna University, and Superintendent of the botanic garden, in establishing botany as a recognized academic subject. Pre-eminent among these sixteenth-century botanists was Charles de l'Ecluse, known as Clusius (1526–1609). He too first concentrated on establishing his academic credentials, but in 1564 he turned to plant-hunting and published his findings in several works, culminating in 1601 with *Rariorum Plantarum Historia*, which became one of Linnaeus's own starting points. Clusius visited Spain and England (where he investigated plants found on Drake's voyages, including potatoes), but after 1573 his main base was Vienna, where the Hapsburg Emperor Rudolph II invited him to superintend his collections of botanical rarities. In this benign atmosphere (Giuseppe Arcimboldo, famed for his unconventional portraits in the form of fruit and vegetables, was even permitted to include the Emperor among his sitters) Clusius cultivated the plants newly introduced into Europe from Turkey – fritillaries, yellow roses and above all tulips. When he returned to the Netherlands around 1590, with his own precious collection of plants, to become Professor of Botany at Leyden and Superintendent

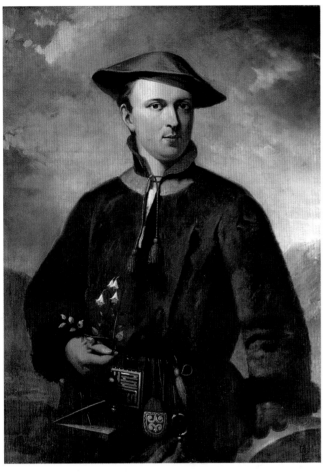

published *Theatrum Botanicium* he could describe over three hundred plants – although somewhat muddled in a classification system with categories such as hot, cool, venomous and unordered. Gerard and Parkinson – and also the elder John Tradescant and his son John, with their plant-hunting expeditions – are well remembered. Less well known is the finest seventeenth-century botanist, John Ray, whose *Historia Plantarum* (published 1682–1703) offered a brilliant system of plant classification, prefiguring Linnaeus by dividing plants into species, but using a series of criteria too complex for mere mortals to grasp.

What the seventeenth century almost entirely lacked was botanical publications with coloured illustrations. In 1613 a noble effort was accomplished by Basilius Besler, a doctor and plantsman of Nuremberg, who organized the production of *Hortus Eystettensis*, recording the numerous plants collected by the Prince Bishop of Eichstatt, which Besler himself had helped to locate and propagate. As well as the latest cultivars of garden favourites such as anemones and poppies, there were American novelties including cannas. But such a project depended on the interest and wealth of one patron. The same applied to the seventeenth-century kings of France. Their plant collections, nurtured by their head gardeners – most notably Jean Robin – were recorded in a series of folios known as *Les Velins du Roi* which began in 1608 with *Le Jardin du tres Chrestien Henri IV* (Henri IV was the Protestant monarch who before his accession said Paris was worth a mass). The

of the botanic garden, Clusius was regarded as the founding father of Dutch pre-eminence in horticulture.

In England the excitement over new plants was expressed in the lyrical descriptions of John Gerard's *Herbal*, published towards the end of Queen Elizabeth's reign and dedicated to his employer Lord Burghley: 'What greater delight is there than to behold the earth apparelled with plants as with a robe of embroidered work set with orient pearls?' Gerard referred frequently to plant exchanges between England and Europe, reaching as far as Constantinople. In 1640 when John Parkinson

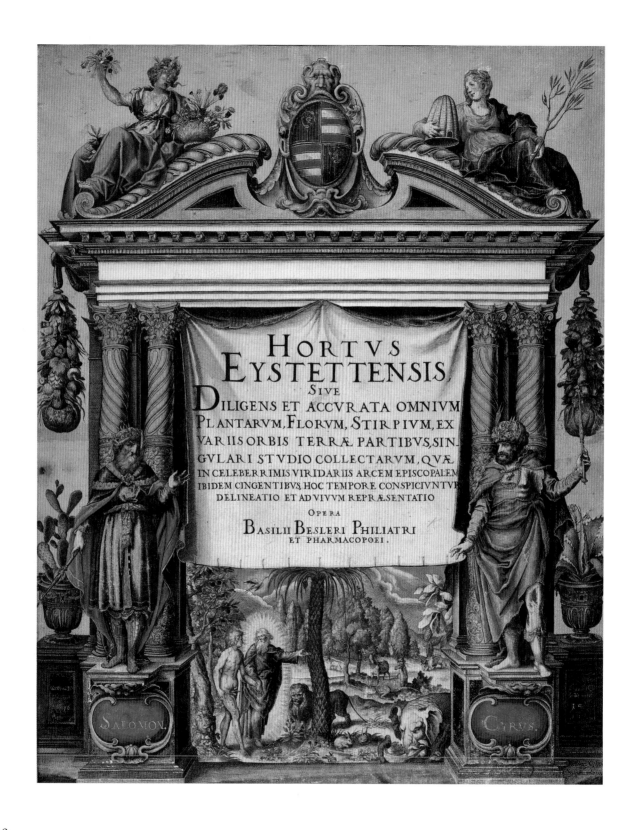

HORTVS
EYSTETTENSIS,
SIVE
DILIGENS ET ACCVRATA OMNIVM
PLANTARVM, FLORVM, STIRPIVM, EX
VARIIS ORBIS TERRÆ PARTIBVS, SIN-
GVLARI STVDIO COLLECTARVM, QVÆ
IN CELEBERRIMIS VIRIDARIIS ARCEM EPISCOPALEM
IBIDEM CINGENTIBVS, HOC TEMPORE CONSPICIVNTVR
DELINEATIO ET AD VIVVM REPRÆSENTATIO
OPERA
BASILII BESLERI PHILIATRI
ET PHARMACOPOEI.

SALOMON. CYRVS.

early paintings included sprekelia from America and haemanthus from Africa. By the reign of Louis XIV *Les Velins* were being superbly illustrated (though not published) by Nicholas Robert and the competitive atmosphere was intense. The royal gardens at Versailles were redesigned by le Notre, the royal gardener de la Quintinie had to produce more succulent fruit, the plant hunter Charles Plumier had to discover more American plants (he described the first fuchsias and cockleshell orchids) and the royal botanist Joseph Pitton de Tournefort had to solve the problems of nomenclature. This he did with aplomb by discarding the complexities of John Ray and using flowers as the basis of classification. He chose the petals rather than the inner sexual parts, but his system opened the way for Linnaeus. Tournefort's great work was *Elements de botanique* published in 1694, but his most famous was *Voyage to the Levant*. Instructed by the King and accompanied by the artist Charles Aubriet, he explored through Greece and Turkey to the Black Sea (where *Rhododendron ponticum* awaited him). Alternately arousing mirth and suspicion, Tournefort collected hundreds of plants, but the *Voyage* was published without colour.

Louis XIV's concept of aggrandisement, especially the wars over Belgian territory, drained the French coffers, while Holland, struggling so valiantly against him, was buoyed up by the wealth of its overseas trade and colonies. By the turn of the century, the highest point of the golden age of plant discovery, the Dutch were in command. Their floras (containing systematic descriptions of the plants of a region) were compiled by botanists who lived in the tropics. For instance the governor of Malabar on the south-west coast of India, H.A. van Rheede tot Draakestein, produced twelve great volumes entitled *Hortus Indicus Malabaricus* (published 1678–1703), including the first engravings of tropical orchids. And in Indonesia George Eberhard Rumf, who arrived on the island of Amboina in 1653 and stayed there till his death in 1702, produced another twelve volumes entitled *Herbarium Amboinense*. The misfortunes faced by Rumf – bereavement, the onset of blindness in 1670 and the loss of his manuscripts – became the stuff of legend, matched only by his persistence and powers of observation. The illustrations of his published work were uncoloured, but in the field he had a botanical illustrator, Pieter de Ruyter, who captured the opulent beauty of tropical flowers such as caesalpinia, lotus and the pitcher plant.

On the sea routes to the east, the Dutch East India Company founded Cape Town in 1652 with vegetable gardens to supply the ships, and a fort for protection. Since the flowers of South Africa are among the most varied and ornamental in the world, tempting bulbs and descriptions filtered back to Europe. In 1672 and 1680 Paul Hermann was the first professional botanist to visit the Cape (on his way to and from Ceylon) collecting all he could on both occasions, and inspiring the Superintendent of the Cape Town garden to go on expeditions inland. Back in Holland their compatriot Jan Commelin made the physic garden in Amsterdam as eminent for its hothouse collections and its teaching as the older botanic

garden at Leyden. After his return from travelling Paul Hermann was appointed Professor of Botany at Leyden, stimulating a friendly rivalry between the two institutions and a profitable exchange of plants and information. In 1698 Hermann published a flora of Indonesian plants, *Paradisus Batavius*, while Commelin produced a most impressive florilegium with colour plates showcasing his exotic plants – agapanthus, aloes, amaryllis, arctotis and so on through the alphabet. The full title began *Horti medici Amstelodamensis rariorum descriptio et icones* (published 1697–1701).

Also in the 1690s Maria Sibylla Merian, a member of a dynasty of artists, engravers and publishers, and herself well established as a flower painter, moved to Amsterdam, and there 'saw with wonderment the beautiful creatures brought back from the East and West Indies'. These were the natural history collections put on public display by leading Dutch citizens, and Merian resolved (in 1699, aged 52) to set out herself for the tropics to study the relationships between plants and insects. She shared the prevailing belief of early science that God might be reached through investigating the wonders of his creation, and she travelled to tropical America as a member of a Protestant sect. The Labadists preached a return to the simplicities of early Christianity and had a missionary outpost (including a sugar plantation) in Surinam in the Dutch West Indies. 'Everyone', wrote Merian, 'is amazed that I survived at all', but she returned triumphant in 1701 and published her *Metamorphosis* in 1705. There were sixty colour plates full of an uneasy narrative between magnificent

plants and predatory insects, and its success helped to prove that expensively illustrated natural history books had a market. In making botany fashionable, the Dutch Stadtholder William of Orange (1650–1702) and his wife Mary (1662–94) did the nation proud with their own passionate enthusiasm for collecting plants, which in turn encouraged emulation among their courtiers, especially when it came to cacti and succulents. In 1688 William and Mary (both descended from the Stuart kings of England) were invited to replace the intransigent James II on the English throne, and their interests gradually shifted towards England. At Hampton Court Palace the Glass Case Garden came alive with rarities, and English plant-collecting gained a new momentum, with botanists moving in the highest circles.

These circles included Henry Compton, Bishop of London from 1675 to 1713, with added responsibility for appointing chaplains to the American colonies, an opportunity he seized to encourage the collection of American plants. His most enthusiastic chaplain was John Banister who, first in the West Indies and then in Virginia, compiled a catalogue of American plants – the first to be published, because John Ray gratefully incorporated it in *Historia Plantarum*. Here were the first descriptions of American rhododendrons, magnolias, rudbeckias and dodecatheons. Simultaneously Bishop Compton was able to fill his grounds at Fulham Palace with a rare collection of trees and shrubs and his glasshouses with exotics. Knowing 'the great delight he himself took in observing the same, so did he freely admit others

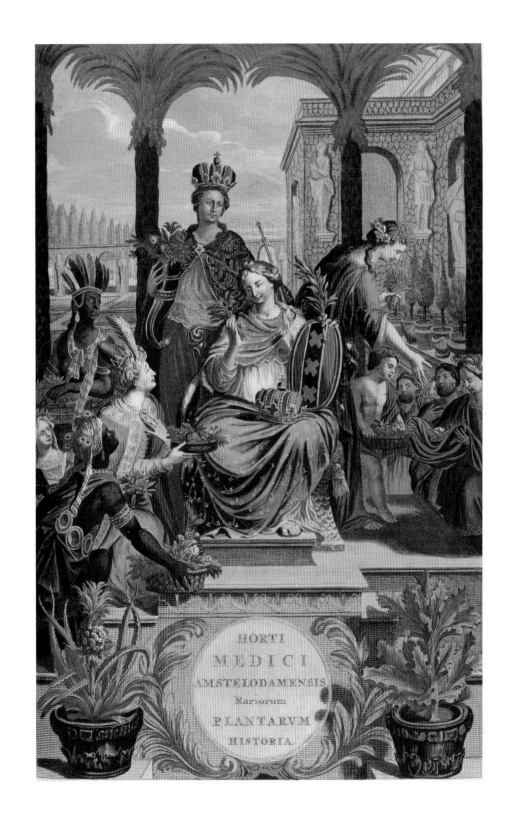

HORTI
MEDICI
AMSTELODAMENSIS
Rariorum
PLANTARVM
HISTORIA

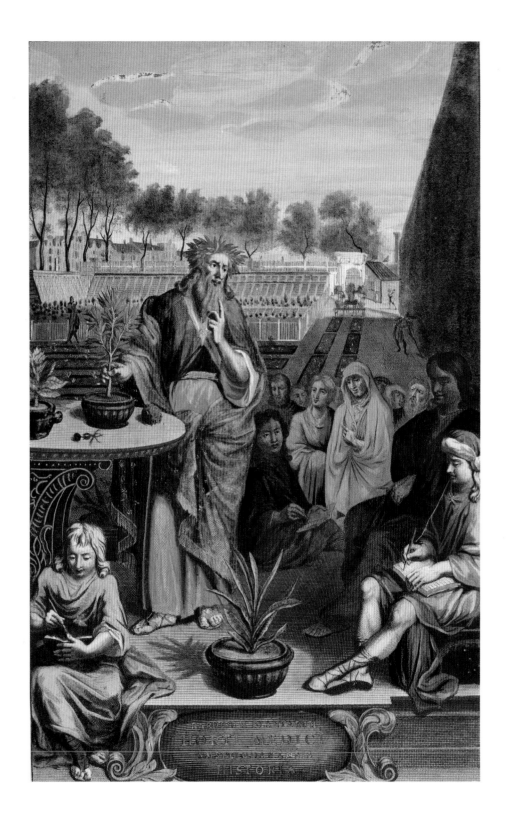

curious in botanism to do the like'. Among the admiring company one may imagine John Evelyn (whose book on arboriculture named *Sylva* was more famous in his lifetime than his *Diary*); and Sir Hans Sloane, patron of the Chelsea Physic Garden and of early eighteenth-century botanists. Sloane gained his own plant-hunting credentials when he returned from Jamaica in 1689 with many dried specimens and the embalmed body of his employer the Duke of Albemarle. Nearby in Chelsea were the palatial gardens of Mary, Duchess of Beaufort. Like Maria Sybilla Merian (whose paintings were copied for her) and Queen Mary, who was her friend, she proved that serious botanizing was not just for men. While the Duke of Beaufort steered his course through the shifting allegiances of the age, she pursued horticulture with skill and determination for over fifty years, endlessly listing, noting, pressing and trying to identify her specimens. Her extensive library included annotated copies of Commelin and Draakestein and her herbarium is preserved with Sir Hans Sloane's in the Natural History Museum. She had a reputation for restoring ailing exotics to health as no one else could. Her lists of succulents ranged from aloes and euphorbias to stapelias and yuccas; and plants she recorded that were then unusual, though now familiar, included pelargoniums, nerines, hibiscus, arum lilies, passion flowers and datura.

During the ensuing century many aristocrats poured their wealth and influence into furthering horticulture and its attendant publications, some because they wanted their newly designed landscape gardens to include impressive plantings, others with genuine expertise – like the Duke of Argyll at Whitton and Lord Petre at Thorndon. Noble patronage extended not only to leading designers like Charles Bridgeman and Capability Brown, but also to gardeners who, having gained experience of growing exotics, turned out to be canny entrepreneurs. George London, employed first by Bishop Compton and later by William and Mary, set up his own nursery at Brompton to cater to the increasing market for plants. James Gordon, gardener to Lord Petre, established a nursery at Mile End after the latter's death in 1743. He introduced camellias and gardenias to commerce and earned praise even from the green-fingered merchant Peter Collinson: 'I never heard of any man that could so raise the dusty seeds of kalmias and rhododendrons.' In Hackney Conrad Loddiges specialized in tropical orchids; in Hammersmith James Lee, previously gardener to the Duke of Argyll, received seeds from Botany Bay and concentrated on South African and Australian plants – although his greatest moment of fame was associated with a fuchsia. At Hoxton Thomas Fairchild experimented with hybridization and almost delivered a paper on the subject to the Royal Society. Christopher Gray, the specialist in American plants, salvaged plants from Fulham Palace when Bishop Compton died in 1713, and continued into the 1770s as a leading supplier of plants from America. Even the redoubtable Philip Miller was a market gardener until Sir Hans Sloane made him Curator of the Chelsea Physic Garden. From this vantage point Miller's *Gardener's*

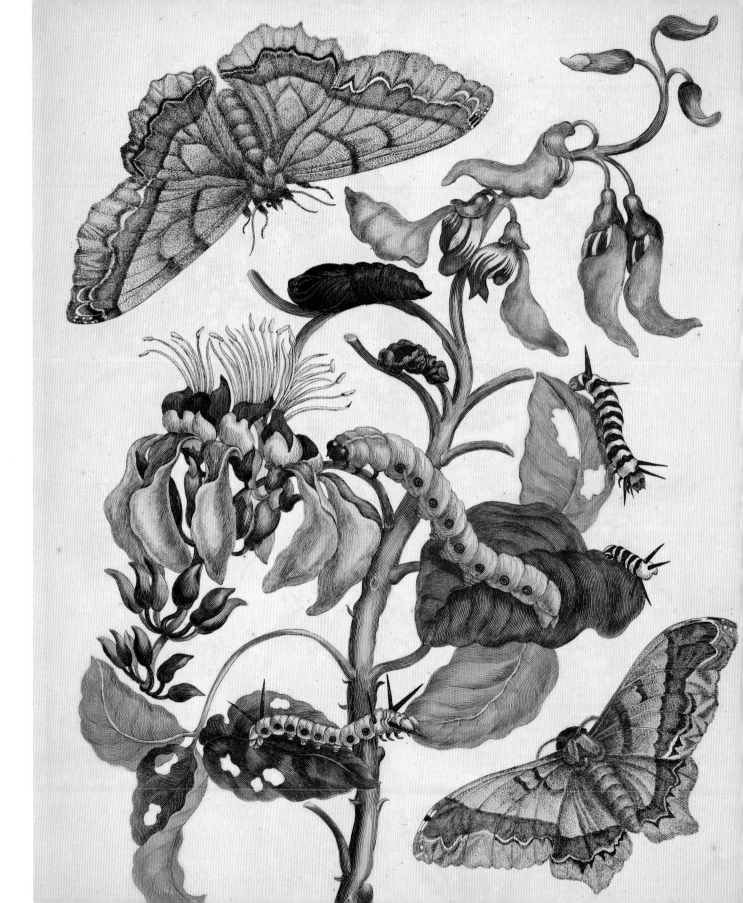

Dictionary, published in many editions starting in 1731, became the bible of new plant introductions and how to cultivate them, and was much quoted at the end of the century in the *Botanical Magazine*. Miller memorably tried to put the young Linnaeus in his place, and resisted his ideas until late in life.

All this effort and excitement would have been nothing without the travels of plant hunters like Mark Catesby (1682–1749). Inspired by his predecessors Charles Plumier and Maria Sibylla Merian, and making use of the undoubted advantages of an uncle who knew John Ray and a sister who was married to a doctor in Williamsburg. Catesby spent seven years exploring Virginia, from 1712 to 1719, with a trip to Jamaica in 1714. He sent seeds to Thomas Fairchild, and on his return his drawings so impressed William Sherard and Sir Hans Sloane that they headed up a subscription towards the expenses of a return visit from 1722 to 1726 which included Carolina, Georgia, Florida and the Bahamas. After that Catesby settled down, working first with Thomas Fairchild, then Christopher Gray. In 1733 he became a 'greatly esteemed' fellow of the Royal Society, and devoted his life to producing *The Natural History of Virginia, Carolina etc*. Catesby understood that 'the illuminating [meaning colouring] of natural history is so particularly essential to the perfect understanding of it'. He enlivened his plants by including the creatures associated with them (most successfully birds, but once even a bison). This was also, as he endearingly admitted, 'for economy' since combining two subjects in one plate reduced production expenses. Catesby's first set of twenty plates appeared in 1729 and later ones continued until shortly before his death in 1749 – indeed after it, since Christopher Gray published the popular *Hortus Europae-Americanus* from Catesby's plates in 1767, including the first image of witch hazel.

Another powerful figure on the scene was Peter Collinson, a City cloth merchant who helped to cover the production costs of Catesby's *Natural History*, 'else through necessity it must have fallen prey to the bookseller'. Collinson's own garden – described as small, neat and crammed full of rarities – was in Peckham until he inherited a much larger property at Mill Hill. He used his business connections overseas to obtain plants and his growing expertise led him into correspondence even with Linnaeus. His most fruitful contact was John Bartram, a Pennsylvania farmer turned plant hunter who undertook to send approximately twenty boxes each year packed with seeds and plants for five guineas apiece. American plants which hitherto had been scarce and all too likely to die out – like calycanthus, cornus, liriodendrons and magnolias – increased in supply and naturally demand also rose. By 1740 Collinson and Bartram were in 'a settled trade and business', which continued until the former's death in 1768, supplying enthusiasts from Philip Miller to the Dukes of Richmond, Norfolk and Bedford.

Later in the century John Slater, a director of the East India Company, was also a City patron of plant importation, himself collecting roses and camellias while encouraging employees of the company to

17

explore the botany of the Far East and its economic potential. William Roxburgh was pre-eminent in investigating different species of Indian plants and their varying attributes, from acacias to cotton and spices. He first arrived in India in 1766 as an East India Company doctor stationed in Madras. From the start he cultivated a garden of economic and medicinal plants and owed much to his friendship with the Danish botanist John Gerard Koenig, a pupil of Linnaeus and doctor to the Danish settlement, who was employed as a naturalist by the Nabob of Arcot. Koenig's contribution is acknowledged in the preface to Roxburgh's great work *Plants of the Coast of Coromandel* (published 1795–1819), which was compiled from the notes they made together on field trips. In 1793 Roxburgh was appointed Director of the Botanic Garden in Calcutta, which had been founded with the support of the East India Company. There his notes for publication were much enhanced by harnessing the skills of Indian artists to provide the illustrations. At this time not only Roxburgh but his contemporaries in India, Thomas Hardwicke, an officer in the company's army, and the Governor General Marquess Wellesley, sponsored valuable collections of natural history drawings by Indian artists.

As a young botanist Joseph Banks also owed much to a pupil of Linnaeus, Daniel Solander, who accompanied him aboard Captain Cook's first *Endeavour* voyage of 1769–71, in order to help identify the plants. When they reached the fabled *Terra Australis*, which George III had instructed them to explore and claim, they named their landing place Botany Bay, so richly were their hopes rewarded with extraordinary flowers. When all their dried specimens were finally catalogued and named they reached a staggering 1300, and the illustrations made by Sydney Parkinson, the botanical artist of the voyage, brought them to life. The collections were curated by Solander and botanists came from all over Europe to view them in Banks's library, but they were not published. Instead another leading botanist, James Edward Smith, responded to the widespread interest with *A Specimen of the Botany of New Holland* (1793), skilfully illustrated by the prolific botanical artist James Sowerby, who pioneered printing techniques that would make colour plates economically viable. Sowerby also contributed many plates to the *Botanical Magazine*, first published by the nurseryman William Curtis of Lambeth in annual editions from 1787 to 1801. As well as illustrations, descriptions and cultivation notes, occasionally the *Botanical Magazine* brought personalities vividly to life. An anecdote relating to a rare pelargonium revealed the opportunism of the Hammersmith nurseryman James Lee: 'on looking through the possessions of Joseph Banks recently received from the Cape he spotted a few ripe seeds which he solicited and obtained, and to his success in germinating them we owe this plant'.

Since Joseph Banks was an affluent member of the landed gentry of Lincolnshire, with a degree in botany from Oxford and outstanding credentials as a plant hunter, small wonder that his friend George III invited him to direct and develop the royal collections already assembled at Kew Gardens.

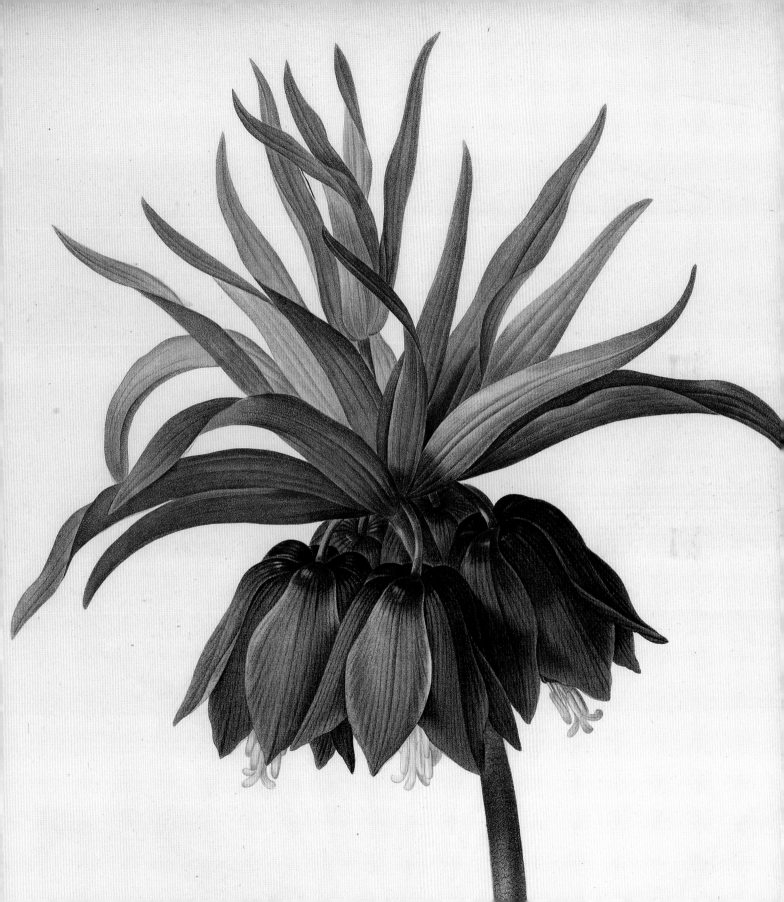

To this Banks devoted his huge energy and networking skills, backed by his scientific status as President of the Royal Society. Many of those serving overseas, like William Roxburgh, were encouraged to supply him with plants and information to supplement the official expeditions sponsored by Kew. Of the latter the most memorable may have been Captain Bligh's voyage on the *Bounty* in search of breadfruit, but Francis Masson, quietly amassing the floral treasures of South Africa, was the outstanding plant collector of the late eighteenth century. During his first visit from 1772–5 (when he too joined up with a Linnaean disciple, Carl Thunberg) and a ten-year residence from 1786, he dispatched many previously unknown species including proteas and strelitzias. Masson's own favourites seem to have been stapelias, on which he wrote and illustrated a monograph; and it was he who supplied the ericas which Francis Bauer illustrated with such meticulous delicacy.

Francis Bauer and his brother Ferdinand began their careers as botanical artists in Vienna, working for the Professor of Botany, Nikolaus Jacquin, on the *Icones Plantarum Rariorum* (1781–93), a splendid florilegium commissioned by the Hapsburg Emperor Francis I. To Vienna in 1784 came John Sibthorp, son of the Professor of Botany at Oxford, to research the plants in the *Codex Vindobonensis*, the oldest surviving copy of Dioscorides' first-century herbal, which had dominated European medicine ever since. Sibthorp intended to travel to Greece and Turkey to identify the plants mentioned by Dioscorides, and to produce the ultimate flora

of Greece. (Long after his death, and thanks to the intervention of J.E. Smith, twelve volumes were eventually published.) In 1784 Sibthorp coaxed Ferdinand Bauer to join him, thus ensuring the visual success of *Flora Graeca* and precipitating Ferdinand Bauer's far-flung career as a botanical artist, most notably in Australia. In 1788 the quieter brother Francis Bauer travelled to London with Jacquin's son, who wrote home about the zeal of English botanists: 'if you have uncertainty about plants, then here is the place to reach certainty'. Thereupon Joseph Banks, the great purveyor of certainty, poached Francis to become the resident artist at Kew.

English botanical pre-eminence also attracted the German artist Georg Ehret, whose visits to a succession of eminent gardens inspired his botanical illustrations. In 1737, early in both their careers, he met Linnaeus while the latter was working on the plant collections of the Amsterdam banker George Cliffort. Linnaeus compiled a descriptive catalogue, *Hortus Cliffortianus*, using his new sexual classification system, and Ehret supplied twenty plates, complete with details of the flower parts, which became standard practice in botanical illustration. In England Ehret often worked at the Chelsea Physic Garden (he married the Curator Philip Miller's sister-in-law) and the Duchess of Portland regularly entertained him at Bulstrode, where her exotics were housed in one of the finest gardens of the period. The Duchess was a friend of Queen Charlotte and the artist Mrs Mary Delany, who was patronized by the Queen. Mrs Delany

recorded in her diary 'Oct 1768 poor Ehret begins to complain of his eyes, he has hurt them with inspecting leaves and flowers in the microscope in order to dissect them'. In terms of publication, the wealthy Nuremberg bibliophile Dr C.J. Trew was Ehret's great collaborator, and a lifelong friend. Together they produced *Plantae Selectae* (published 1750–90) and *Hortus Nitidissimus* (published 1750–72) based on Ehret's work in 'the gardens of the curious in London', which he sent to Trew in Nuremberg.

Meanwhile in Paris, Joseph Redoute, the most remarkable and productive botanical artist of the golden age, began his career in 1782, joining his brother – who designed theatre sets. As he sketched in the garden of the Tuileries he was discovered by the French botanist Charles Louis l'Heritier, who hired him to illustrate *Stirpes Novae* (published 1784–85), and in 1787 took him on a visit to Joseph Banks (which included staying with James Lee in Hammersmith and investigating the printing techniques of James Sowerby). On his return to Paris Redoute joined the team still producing *Les Velins du Roi*, which was headed by Gerard van Spaendonck (despite the Revolution the work continued under another name), but in 1798 Redoute moved to Malmaison to record the wondrous collections of the Empress Josephine – who perhaps owed her passion for exotics to memories of her youth in Martinique. Her hothouse plants were celebrated in *Description des plantes rares cultivées a Malmaison*, with a text by the botanist Aimé Bonpland (who himself returned from plant hunting in South America in 1804). Josephine's unparalleled rose collection representing every species, hybrid and variety available at the turn of the century was recorded in *Les Roses* (not published until 1817); while *Les Liliacées*, Redoute's absolute masterpiece, ranged widely through the monocotyledons from ginger and kniphofia to tulips and tropical orchids – reaching a total of 486 plates. The appearance of succulents and liliaceous plants was particularly hard to preserve in any other way than through botanical illustration, and the rationale of his life's work was summed up in Redoute's own words:

'Naturalists have long regretted their inability to conserve the Liliaceae in their herbaria. But the accuracy of the depiction here will save them the trouble of trying. They will find the faithful image of each individual plant. As will the simple amateur who, without desiring to learn the science, is curious to know the characteristics and history of these plants.'

The Plants

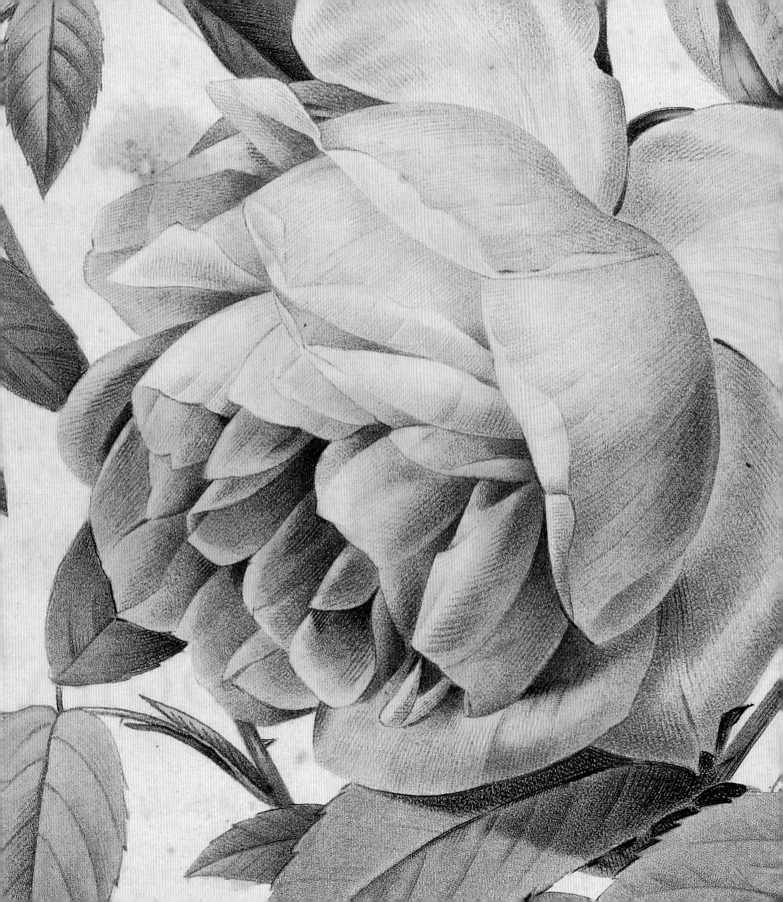

Acacia

WHEN William Roxburgh arrived in India in 1766 he found acacias unrivalled in their range of uses and their curious beauty. For centuries their resin had been traded from east to west, earning the name gum arabic. In India acacias were also used to shade livestock, crops and homes. From the branches came fuel and fodder. The timber was both flexible and durable, good for shipbuilding, carriage wheels, tea chests and coffins. The bark provided tannin and dyes 'much in use among the chintz painters'. One acacia offered a cure for gonorrhoea, from another the Indians 'distilled an ardent spirit', and from the flowers scents were extracted.

William Roxburgh, *Plants of the Coast of Coromandel*, London, 1795–1819. 10.Tab.34, Vol. 2, f.120.

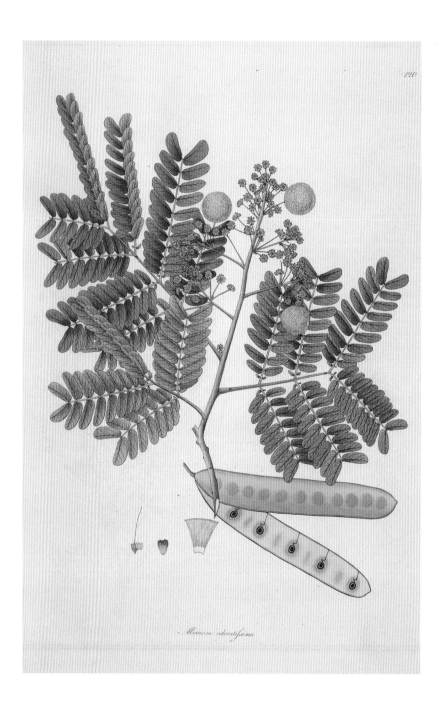

Mimosa odoratissima

Agapanthus

AGAPANTHUS was one of the first flowers to arrive from South Africa. In 1629 John Parkinson described it as 'gathered by some Hollanders on the west side of the Cape of Good Hope' and, after being rather vaguely called blue lily or African hyacinth, it earned the more striking name agapanthus, inspired by the Greek words for 'love flower'. But it took several decades of patient nurturing before any flowers appeared. Commelin, at the botanic gardens in Amsterdam, admitted that an agapanthus had bloomed first under the care of Paul Hermann in the rival botanic garden at Leyden. Meanwhile in Amsterdam the agapanthus flowered and produced seed (and was painted) in 1698, after Commelin's death.

Johannes Commelin, *Horti medici Amstelodamensis*, Amsterdam, 1697–1701. L.R.27l.c.1, Vol. 2, f.133.

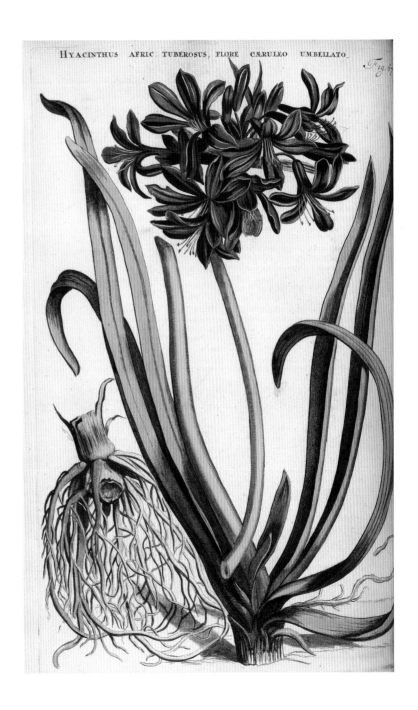

HYACINTHUS AFRIC. TUBEROSUS, FLORE CÆRULEO UMBELLATO.

Aloe

ALOES are African plants but they have a close counterpart in American agaves, suggesting a common ancestor. Both have rosettes of fibrous, prickly leaves and spikes of massed red and yellow flowers. European plant collectors added to their own confusion by transporting *Aloe vera* from North Africa to the Caribbean and naming it Barbados aloe as if it were a native of the New World. It appeared thus in *Hortus Eystettensis*. In the seventeenth century most aloes were reared from seed brought from the Cape. Their collectors included William of Orange and his wife Mary, and also the Duchess of Beaufort (who listed 20 species). Their charms were displayed in ornate pots carved with gods and green men.

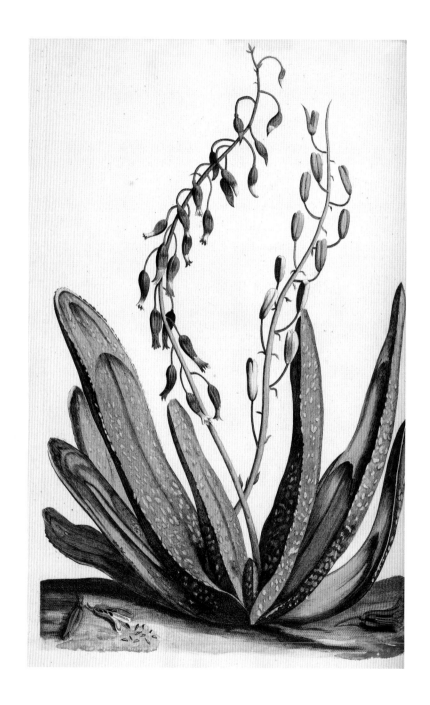

Johannes Commelin, *Horti medici Amstelodamensis*, Amsterdam, 1697–1701. L.R.27l.c.1, Vol.2, f.215.

Alstroemeria *(Peruvian lily)*

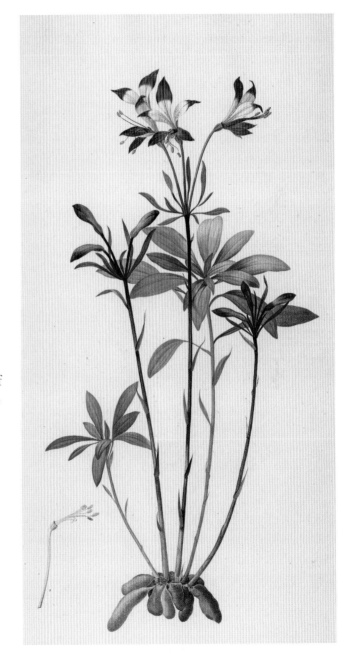

ALSTROEMERIAS have been associated primarily with Peru (although most species originated in Chile) and the poetic name lily of the Incas has been understandably misapplied to them. Their indigenous name *ligtu* was used to denote a species and later the modern hybrids. *Alstromoeria pelegrina* was the first to reach Spain, where in 1753 seeds were sent to Linnaeus by his pupil Claes Alstroemer. Linnaeus named the plant in his honour and tenderly nurtured the seedlings in his bedroom during the ensuing winter. The early alstroemerias were indeed hothouse flowers – the plant illustrated in the *Botanical Magazine* for 1791 'flowered extremely well in the stoves of Messers Grimwood of Kensington', and that painted by Redoute was in the collection of 'Mme Bonaparte' at Malmaison.

Above: *The Botanical Magazine*, W. Curtis London, 1787–1801. 678.c.2 Vols. 3–4, f.125.

Right: Pierre Joseph Redoute, *Les Liliacées*, Paris, 1802–16, 37.i.8, Vol. 1, f.40.

Amaryllis *(Belladonna lily)*

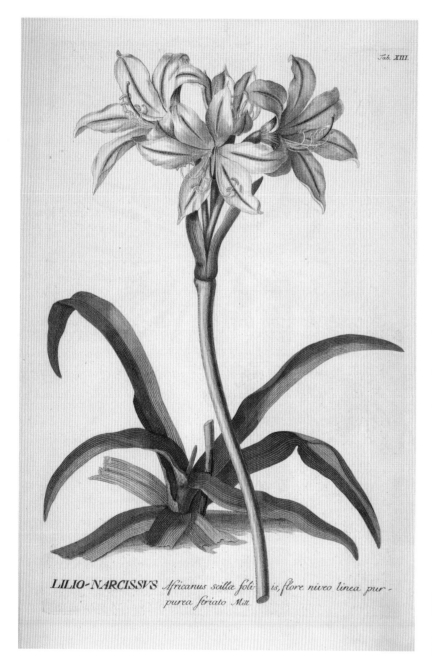

Tab. XIII.

LILIO-NARCISSVS *Africanus scillæ foli- is, flore niveo linea pur-
purea striato Mtt.*

THE ORIGINAL amaryllis with its pretty name evoking nymphs disporting themselves in a classical idyll – and blushing from white to pink and red – came from South Africa into the collections of Commelin in Amsterdam and William and Mary at Hampton Court. This was the original belladonna lily. But also in the seventeenth century various species also called amaryllis or Barbados lily arrived from America; these are now classified as hippeastrum. In the eighteenth century the very similar crinum was introduced from Asia. When European hybrids were developed the original confusion about provenance intensified, while ordinary plant lovers blithely regard them all as amaryllis.

Left: Christoph Jacob Trew and Georg Ehret, *Plantæ Selectæ*, Nuremberg, 1750–90. 36.i.10, f.13.

Opposite: Pierre Joseph Redoute, *Les Liliacées*, Paris, 1802–16. 37.i.8, Vol. 1, f.32.

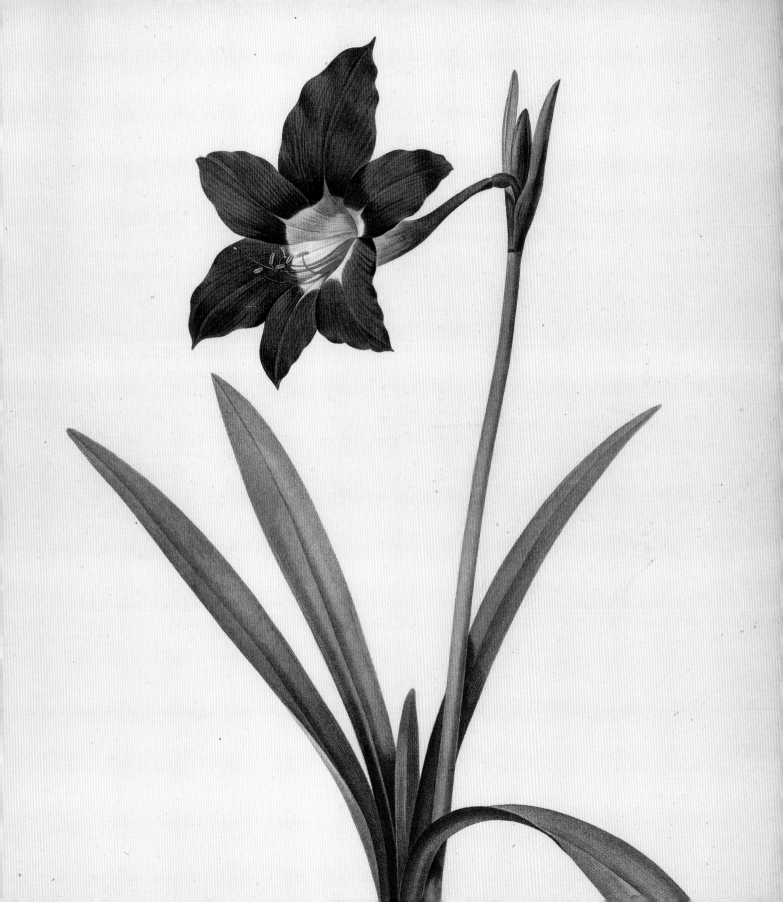

Anemone

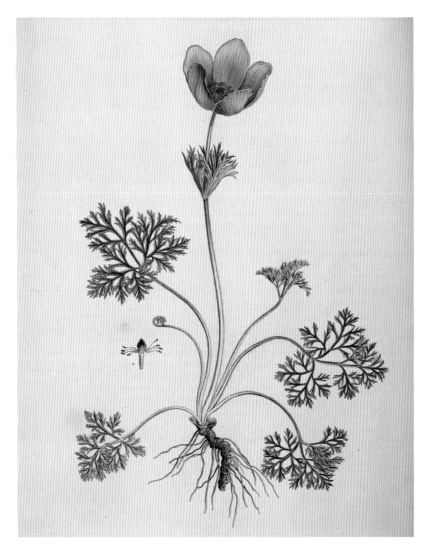

THE WILD anemones of Europe were plentiful springtime flowers, but the garden anemones fashionable in the seventeenth and eighteenth centuries were *Anemone coronaria* and its hybrids, which are native to Mediterranean countries. In cultivation unusual double forms were developed, called plush anemones on account of the velvety cushion of petals in the centre of the flower. An early example was depicted among the collections of the Prince Bishop of Eichstatt published in 1613, before double and striped anemones became the darlings of seventeenth-century still-life painters. The old name 'coronaria' indicated that in classical times anemones were used for garlands, especially associated with the springtime rituals surrounding the death and resurrection of Adonis.

Above: John Sibthorp, *Flora Græca*, London, 1806–40. 453.h.6, Vol. 6, f.514.

Opposite: Basilius Besler, *Hortus Eystettensis*, Altdorf, 1613. 10.Tab.29.

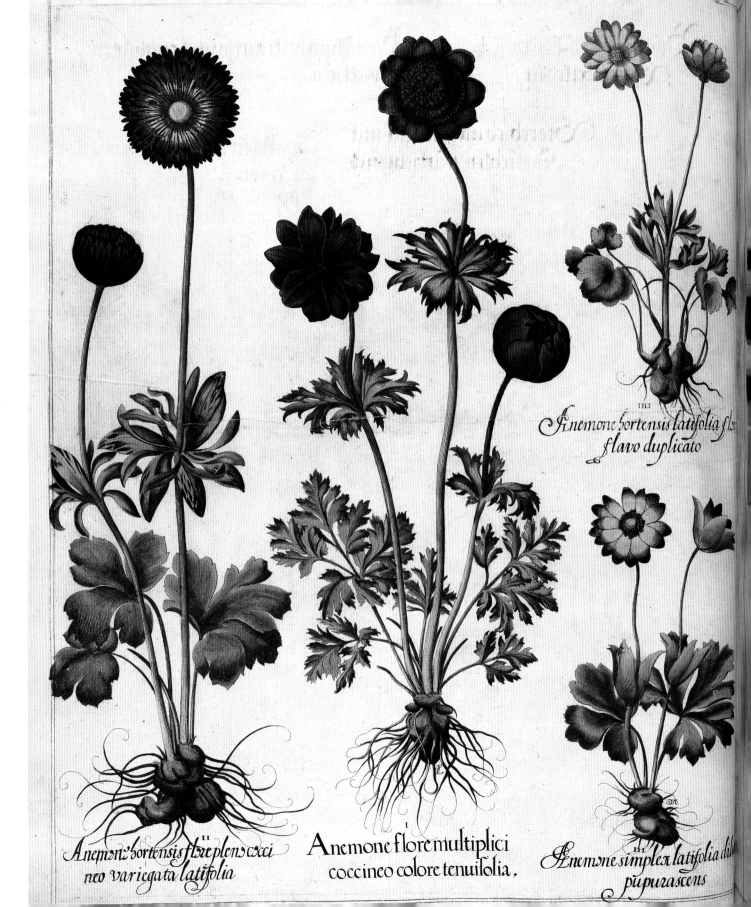

Anemone hortensis latifolia flore
flavo duplicato

Anemone simplex latifolia dilute
pupurascens

Anemone hortensis flore pleno cocci
neo variegata latifolia

Anemone flore multiplici
coccineo colore tenuifolia.

Arctotis

ALTHOUGH it remains little known and hard to grow, arctotis is the loveliest of the South African daisies, producing a range of sunset oranges and pinks. Commelin received it first from the Cape and grew it in his hothouse in Amsterdam. Philip Miller grew it in the Chelsea Physic Garden, which may be where Georg Ehret (who often worked there and married into the family) found the specimen that appeared in *Plantae Selectae* – a book illustrating the rarest plants from the best collections in London. Linnaeus named arctotis from the Greek *arktos*, a bear, presumably on account of its furry seed heads.

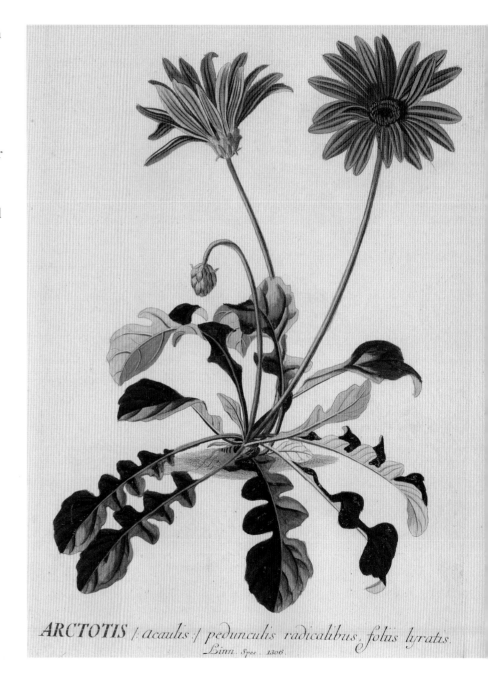

ARCTOTIS *acaulis pedunculis radicalibus, folis lyratis.*
Linn. Spec. 1306.

Christoph Jacob Trew and Georg Ehret, *Plantæ Selectæ*, Nuremberg, 1750–90. 36.i.10, f.93.

Argemone *(Prickly poppy)*

MEXICAN poppies are as prickly as a cactus and initially they were named *Papaver spinosum*. In her painting of argemone, made in Surinam, Maria Sibylla Merian emphasized their aggressive leaves, adding a pincer-laden stag beetle for good measure. Merian's chief objective during her time in the tropics was collecting exotic insects, feeding them, and watching the metamorphosis of the grubs. She explored intrepidly through the jungle: 'I had to send my slaves ahead with axes to hack an opening for me to proceed.' Small wonder her paintings often have a fierce, macabre element, which also reflected the contemporary Dutch fascination with symbols of life and death.

Maria Sibylla Merian, *Metamorphosis insectorum Surinamensium*, Amsterdam, 1705. 649.c.26, f.24.

Arum

ALL OVER the world the flower forms of this plant family, with the phallic purple spadix erect inside the surrounding spathe (and a smell of putrefaction to attract pollinating flies), have astonished observers and earned the plant rude nicknames. In Europe the largest is the dragon arum *Dracunculus vulgaris*, a Mediterranean plant with stems patterned like snake, or dragon, skin. The skunk weed *Symplocarpus foetidus* grew in the swamps of Virginia, where Mark Catesby discovered it and recognized its ornamental potential (sure enough, Peter Collinson gladly accepted it into his garden in Peckham). In the oriental tropics even more sensational arums awaited discovery, the elephant yam *Amorphophallus paeoniifolius* with enormous corms providing edible starch.

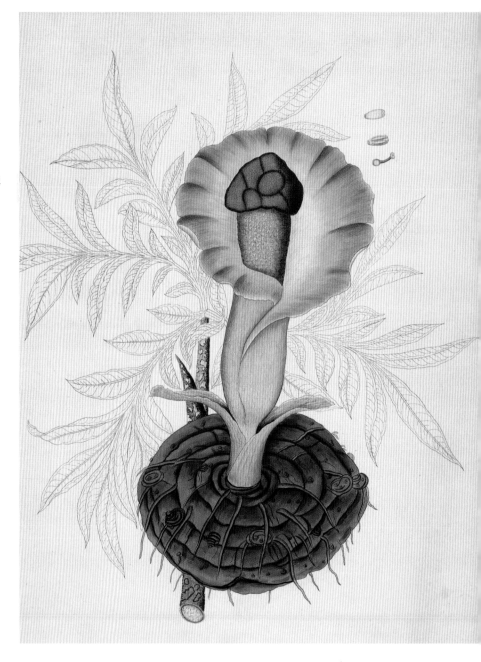

Right: William Roxburgh, *Plants of the Coast of Coromandel*, London, 1795–1819. 10.Tab.34, Vol. 3, f.272.

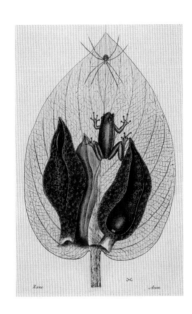

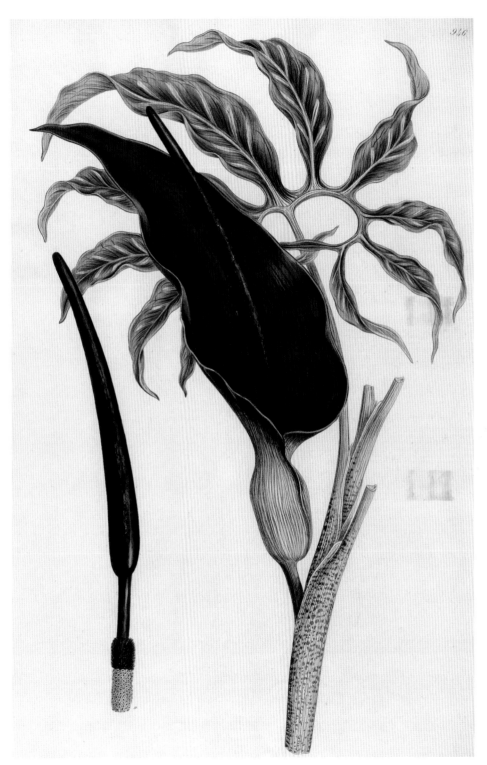

Above: Mark Catesby, *The Natural History of Carolina, Florida and the Bahama Islands*, London, 1754. 44.k.8, Vol. 2, f.71.

Right: John Sibthorp and Ferdinand Bauer, *Flora Græca*, London, 1806–40. 453.h.10, Vol. 10, f.946.

Aster *(Michaelmas daisy)*

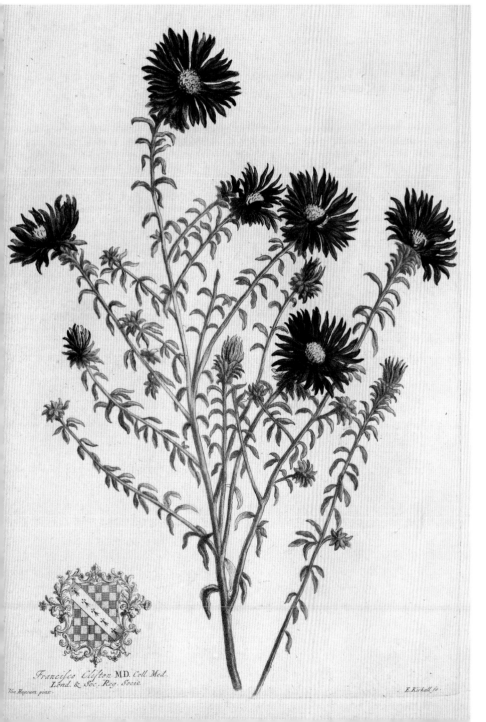

Francisco *Clifton* MD. *Coll. Med.*
Lond. & Soc. Reg. Socio.
Ehret Huysum pinx.

F. Kirkall fe.

ASTERS, meaning star flowers, were first named from Mediterranean species, but those were outshone by new arrivals from North America: *Aster tradescantii* brought back by the younger John Tradescant from Virginia in 1637, *A. novi-belgii* named after the Dutch settlement where the seed was collected (renamed New York when the English acquired it in 1664), and *A. novi-angliae* named after New England in 1710. Mark Catesby introduced *A. grandiflorus* from Virginia in 1726 to Thomas Fairchild's plant nursery in Hoxton, where John Martyn, Professor of Botany at Cambridge, selected the specimen shown here for publication. The name Michaelmas daisy evolved after 1752 when the adoption of the Gregorian calendar meant their flowering coincided with the feast of St Michael on 29 September.

John Martyn, *Historia plantarum rariorum*, London, 1728. 456.h.13, f.19.

Auricula

THE MOUNTAINOUS background used in Robert Thornton's illustration for the *Temple of Flora* was authentic because auriculas were originally alpine flowers, soft yellow or mauve like other primulas, and first brought into cultivation in the sixteenth century by Clusius when he worked in the imperial gardens in Vienna. The flowers were developed for rich, velvety colours contrasting with the pale 'paste' of the centre, and by the 1730s they featured repeatedly in the flower paintings of Jan van Huysum and his followers. As auriculas became collectors' items their colours were catalogued with tempting names – leather-coat, willow, mouse, murrey, black and 'Mistress Buggs her fine purple raised by her in Battersea near London'.

Robert John Thornton, *Temple of Flora*, London, 1799–1807. 10.Tab.40.

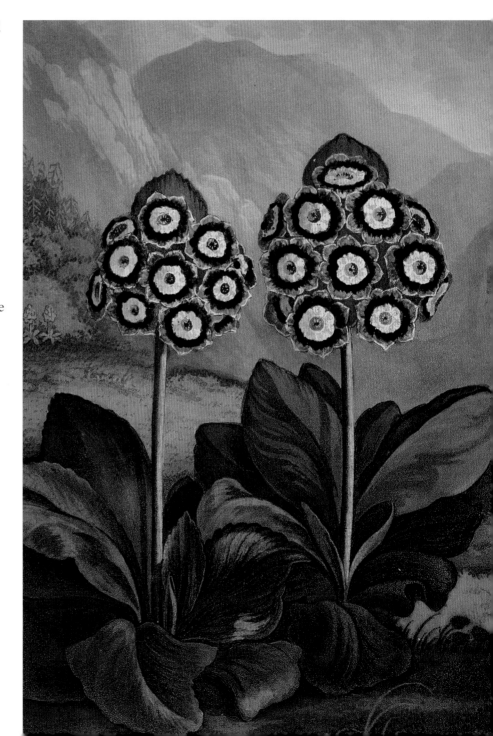

Babiana

IN HIS GARDEN of rarities in seventeenth-century Amsterdam, the most unusual plant that Commelin possessed was *Babiana ringens* from South Africa, which produced an appearance so extraordinary as to seem like an imaginary plant. The strange flowers are designed for pollination by sunbirds, and the central stem evolved to provide them with a perch. Commelin named his fabulous plant *Gladiolo* for its sword-like leaves and *aethiopico*, meaning African. The settlers in the Cape, having noted that monkeys and porcupines ate it, named it baboon-root (hence *Babiana*). Commelin's illustration is the original type specimen from which the species is identified.

Johannes Commelin, *Horti Medici Amstelodamensis*, Amsterdam, 1697–1701. L.R.27l.c.1, Vol.1, f.81.

Banksia

SEEDS of banksia, named after its discoverer Joseph Banks, were among the few living plant materials that he succeeded in bringing back from Australia after the *Endeavour* reached Botany Bay in 1770. The superb illustrations made on the voyage by Sydney Parkinson were not published, but instead in 1793 James Edward Smith published *A Specimen of the Botany of New Holland*, illustrated by James Sowerby, to satisfy 'a nation so deeply interested in the productions of a country of which they have lately heard so much'. Sowerby skilfully based his work on coloured drawings by John White, Surgeon General to the new penal colony, alongside 'a copious and finely preserved collection of dried specimens'.

James Edward Smith and James Sowerby, *A Specimen of the Botany of New Holland*, London, 1793. 443.g.29, Plate IV.

Bombax *(Cotton tree)*

BOMBAX is closely related to the mallow family – including gossypium, which produces the cotton of commerce – but those are shrubs, while bombax is one of the largest trees of India. The cotton tree produces around the seeds a mass of silky white fluff which is a source of kapok, used for stuffing everything from mattresses to quilted garments. The thick trunks have many layers of water storage tissue, creating a soft light wood especially useful for canoes. On his botanical travels William Roxburgh found trees up to 100 feet (30 m) tall growing in the mountains, and at the end of winter, before the leaves returned, admired how the trees were decked in 'many huge, bright red flowers'.

Wellesley Collection, Natural History Drawings. NHD 13, f.62.

Bromeliad *(Pinguin)*

BROMELIADS were among the most sensational plants to enter the hothouses of Europe from the rainforests of tropical America – their curious leaf structure is designed to absorb and store water since they subsist without roots. Several bromeliads produce edible fruits, such as pineapples, which were widely cultivated in South America and the Caribbean before Europeans arrived, who described them as the fruit of the new Eden. This bromeliad, like the other exotics illustrated by Georg Ehret and published in Nuremberg by the bibliophile C.J. Trew, was a plant 'nourished in the collections of the curious in London'. Here Ehret settled in 1738, and succeeded in establishing his reputation as an equal among botanists, although most of his collaborations ended in acrimony, except for his long-distance, lifelong association with Trew.

Christoph Jacob Trew and Georg Ehret, *Plantæ Selectæ*, Nuremberg, 1750–90. 36.i.10, f.51.

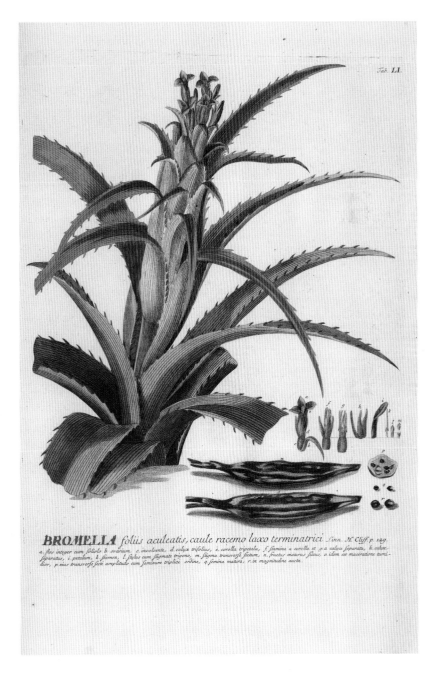

BROMELIA *foliis aculeatis, caule racemo laxo terminatrici* Linn. H. Cliff. p. 129.

Cactus

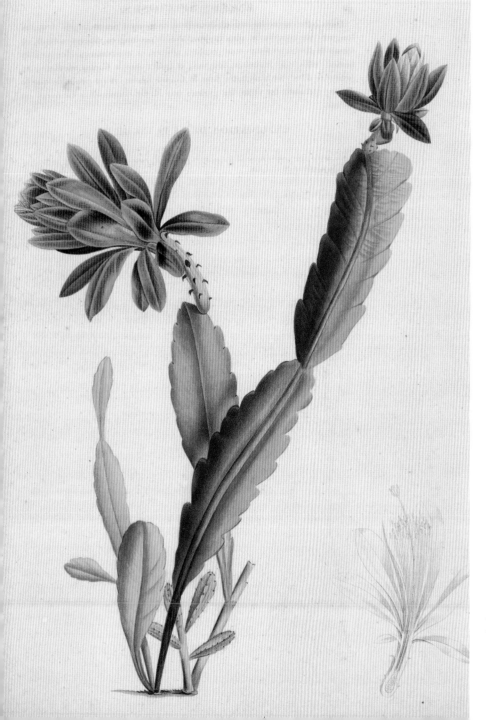

CACTI are not formed to fascinate but to store water in desert conditions and ward off predators with their spines; however, for some their odd beauty proved compelling. The royal collectors William and Mary grew their first cacti in the orangery at Het Loo and shared their fervour with their Dutch counsellors Gaspar Fagel and William Bentinck. After 1689 the exotics were transported (supervised by Bentinck, who became Duke of Portland) to the Glass Case Garden at Hampton Court. In France the seventeenth- and eighteenth-century tradition of botanical illustration under royal auspices, known as *Les Velins du Roi*, survived until the Revolution. The young Redoute was smuggled into the Bastille to paint a flowering cactus for Marie Antoinette and later in his career he painted this cactus from Columbia for the Empress Josephine at Malmaison.

Aimé Bonpland and Pierre Joseph Redoute, *Description des plantes rares cultivées à Malmaison et à Navarre*, Paris, 1813. 460.g.3, f.3.

Caesalpinia *(Paradise or peacock flower)*

CAESALPINIA PULCHERRIMA
(meaning the most beautiful)
was also known as the paradise
or peacock flower for its glorious
burst of display when it flowered.
Caesalpinia is pantropical (found
across the tropics) and the various
species have many uses from timber
to medicines. Initially the Chinese
dispersed *C. pulcherrima*, and during
the seventeenth century the Dutch
followed their example in both the
East Indies – where Pieter de Ruyter
illustrated it – and the West Indies.
Maria Sibylla Merian encountered it
in Surinam, and wrote that the female
slaves on the Dutch sugar plantations
believed an extract from the root
would procure an abortion – which
casts a shadow on the assumption that
the spread of caesalpinia was due to
its ornamental value.

Pieter de Ruyter, *Plants of Amboina*, 1692.
Add. Ms. 11027, f.54.

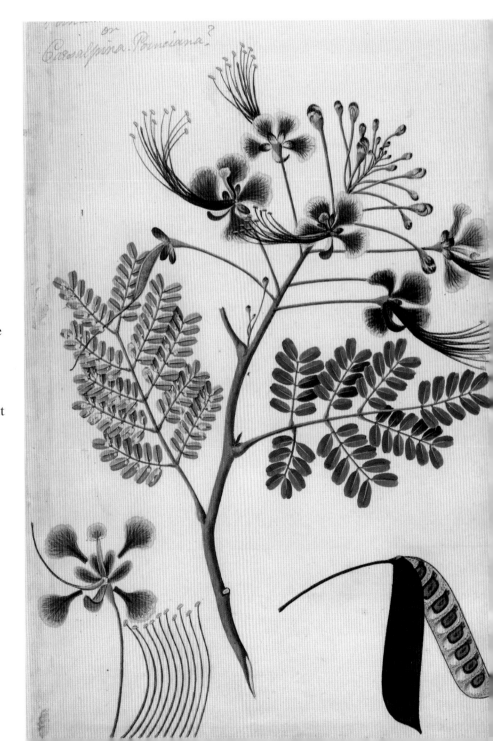

Calceolaria *(Slipper flower)*

IN SOUTH AMERICA the wild species of calceolaria bear single flowers in which the lower petal forms a pouch, like a slipper for stepping into an enchanted world – hence their name, which means little shoe. It is orange or yellow, with spots, streaks and fluffy hairs, all of which are designed to lure insects to fertilize the flower. *Calceolaria fothergillii* was introduced from the Falkland Islands in 1777, after the first British settlers were established there in 1765. Calceolaria grew widespread in the shrubby heathland where the sheep grazed, and on reaching England the species was named in honour of Dr John Fothergill, a leading botanist and generous patron of plant-hunting expeditions.

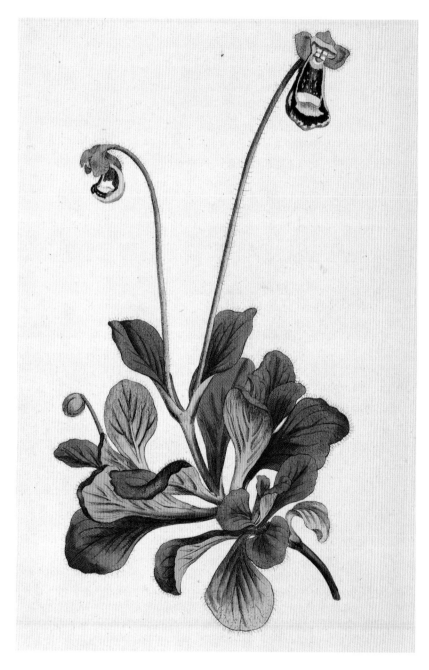

The Botanical Magazine, W. Curtis London, 1787–1801. 678.c.5, Vols. 9–10, f.348.

Callistemon *(Bottlebrush)*

CALLISTEMON is a member of the myrtle family and was initially grouped with metrosideros flowers from South Africa and the Pacific. But as seeds introduced from Australia grew into flowering shrubs it was seen to merit a genus of its own, based on the Greek *kalli*, meaning beautiful, and stemon because the fabulous red fuzz is created by a mass of stamens designed for bird pollination. At Malmaison, Bonpland reared seeds brought back from Captain Baudin's Australian expedition of 1801–02. Originally Bonpland was appointed botanist to the expedition, but war enforced economies and prevented his going. Bonpland retained his admiration for Australian plants – he reckoned callistemon could be cultivated outdoors in the Midi, and praised *l'éclat de ses fleurs*.

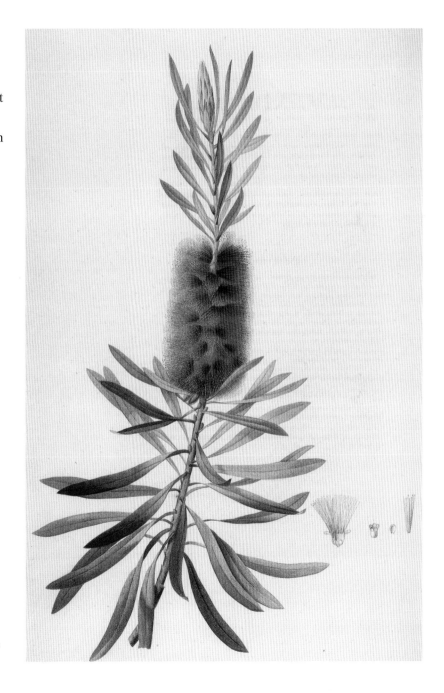

Aimé Bonpland and Pierre Joseph Redoute,
Description des plantes rares cultivées à Malmaison et à Navarre, Paris, 1813. 460.g.3, f.34.

Callistephus *(China aster)*

CHINA ASTERS were first grown from seed in Paris in 1728. An apocryphal story claims that the impact of a flowerbed of pink, white and blue asters inspired Pierre d'Incarville to embark on his career in China where, as a botanizing missionary, he was one of the few Europeans welcomed at the imperial court. Meanwhile the asters became a requisite in eighteenth-century gardens, and on a visit to Paris, Horace Walpole described the garden of Marshall de Biron where the walks were 'buttoned' with nine thousand pots of asters. This was seasonal planting at its most extreme, but asters did provide a precious burst of colour at the end of summer.

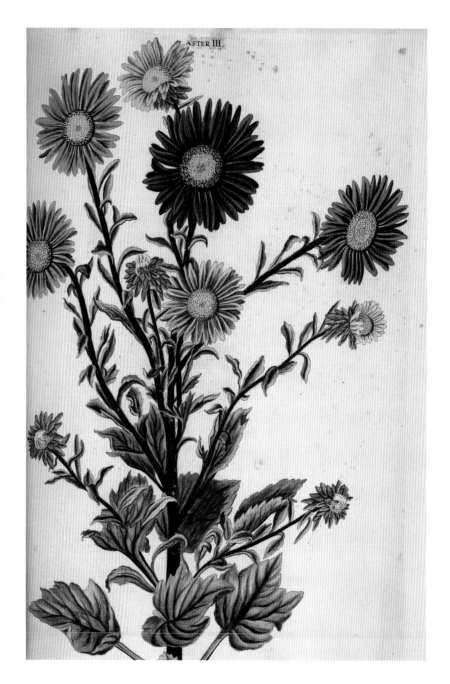

Christoph Jacob Trew and Georg Ehret, *Hortus nitidissimus*, Nuremberg, 1750–72. 38.i.15, f.121.

Calycanthus *(Carolina allspice)*

CAROLINA ALLSPICE or sweet bush was introduced by Mark Catesby in 1726. 'The bark is very aromatic and as odoriferous as cinnamon', he wrote, while its 'stiff copper-coloured petals would fill the air with the scent of pineapples'. Even in America it was uncommon: 'these trees grow in the remote and hilly parts of Carolina but nowhere among the inhabitants'. At first it remained rare in Europe – 'Imagine if one could get calycanthus', Linnaeus wrote longingly, with a view to examining its curious flowers. Then in the 1750s Peter Collinson received a fresh importation from Charlestown, where it was coming into cultivation as a garden shrub, and this calycanthus grew well 'in the open air, bearing flowers abundantly every year'.

Mark Catesby, *The Natural History of Carolina, Florida and the Bahama Islands*, London, 1754. 44.k.7, Vol. 1 f.46.

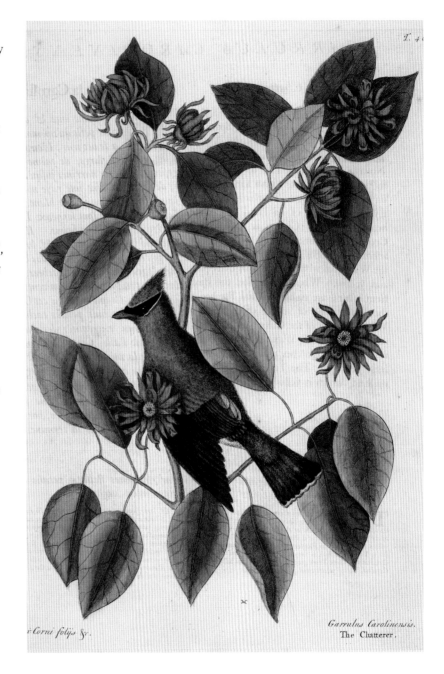

Garrulus Carolinensis.
The Chatterer.

Camellia

THE FIRST camellia bushes to arrive in Europe were 'possible tea plants that nobody wants', perhaps deliberately substituted by the Chinese, who had no wish to export tea production. But, when they flowered, camellias were lovelier than tea, if less lucrative. In 1712 Engelbert Kaempfer, the German botanist who visited Japan, called them the Japanese rose, and in 1740 'their elegant brightness' was admired when Lord Petre's camellias flowered at Thorndon. In 1792 John Slater of the East India Company imported some striped and double camellias, which the *Botanical Magazine* described as 'the properest plants imaginable in the conservatory' (they were too expensive to hazard in the open air).

Above: *The Botanical Magazine*, W. Curtis London, 1787–1801. 678.c.1, Vols. 1–2, f.42.

Opposite: Nikolaus Joseph Jacquin, *Icones plantarum rariorum*, Vienna, 1781–93. 34.h.5, Vol. 3, f.553.

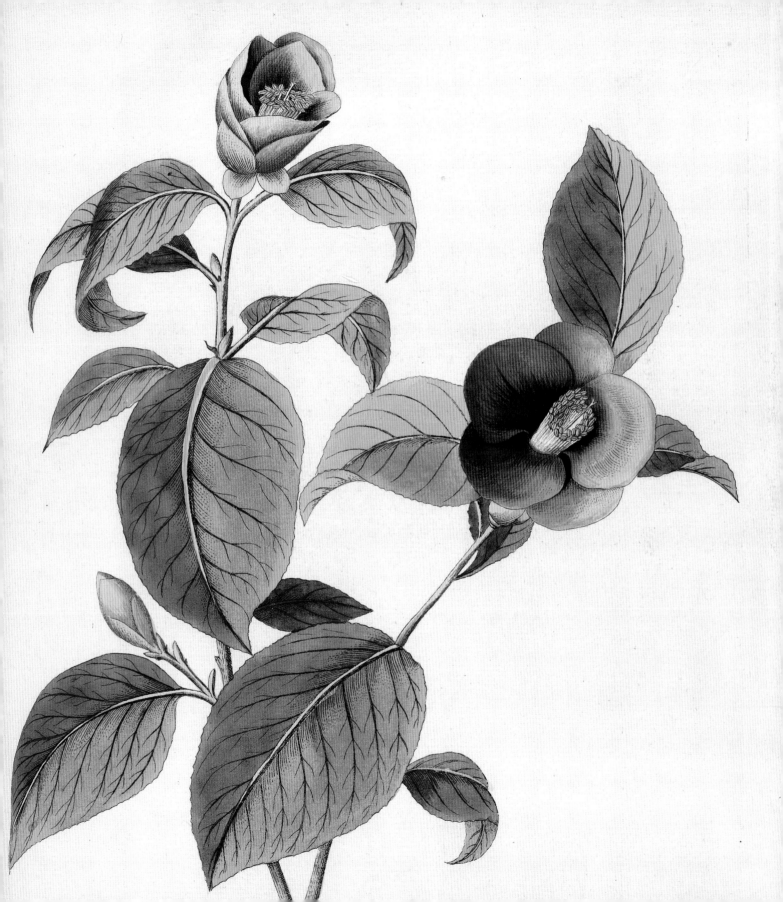

Campsis *(Trumpet vine)*

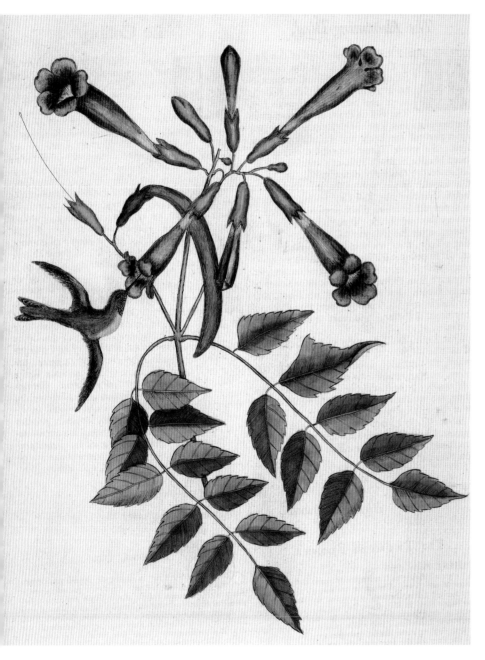

THE TRUMPET VINE captured the attention of the early settlers in Virginia, and John Parkinson described it in 1640 although he had not seen it flower. Mark Catesby, having visited its natural habitat, gave a perfectly observed example of bird pollination. Flying at the flower is 'the Carolina humming bird with a body the size of a humble bee ... and its tongue a tube through which it sucks honey'. The birds would 'rove from flower to flower on which they wholly subsist, and sometimes by thrusting too far into the flower they get caught'. Catesby returned to England in 1726 with seeds and it grew rapidly in popularity. Peter Collinson had it growing in orange profusion over his greenhouse.

Mark Catesby, *The Natural History of Carolina, Florida and the Bahama Islands*, London, 1754. 44.k.7, Vol. 1, f.65.

Canarina *(Canary bellflower)*

THE MOST BEAUTIFUL of campanulas was introduced from the Canary Islands – a little paradise for plant collectors on board ships bound for Africa and beyond. In 1696 canarina was listed growing at Hampton Court, and in the collection of Mary, Duchess of Beaufort, who – according to Hans Sloane – 'brought plants under her care to greater perfection than at Hampton Court or anywhere'. She regularly received plants and advice from George London, the royal gardener, and cited the Queen's botanist Leonard Plukenet as an authority for identification. She also kept methodical lists of seeds, plants and suppliers (including ship's captains) and referenced other collections, keeping an especially close eye on descriptions of Commelin's Amsterdam garden.

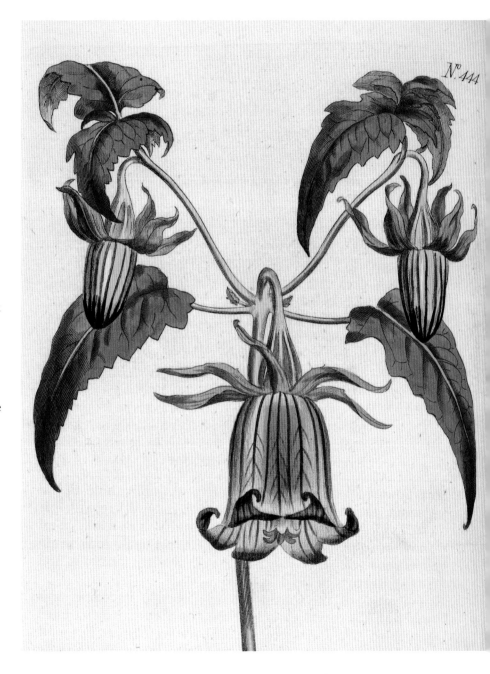

The Botanical Magazine, W. Curtis London, 1787–1801. 678.c.7, Vol. 1, f.444.

Canna *(Indian shot)*

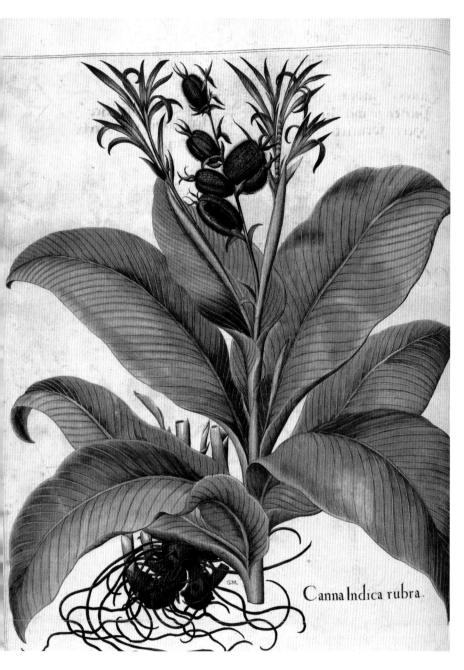

Canna Indica rubra.

IN *HORTUS EYSTETTENSIS* the stately red canna was confusingly referred to as Indian shot, because of the appearance of the round black seeds as they arrived from the West Indies. By the 1740s when Linnaeus's order beds at Uppsala were the centre of the botanical world, cannas had a new importance because they marked the start of the sequence. Linnaeus's new sexual system of classifying plants by numbering the male and female parts of the flower made no attempt to placate either those who preferred previous systems or those who found his emphasis on polygamy offensive. At least the canna, having just one stamen and one pistil, could be referred to as monogamous.

Basilius Besler, *Hortus Eystettensis*, Altdorf, 1613. 10.Tab.29.

Cercis *(Judas tree)*

THE UNFORTUNATE English name, accompanied by the legend that Judas hanged himself from such a tree after betraying Christ, was based on a misunderstanding of the Latin *Arbor Judae*, meaning it grew in Judea, especially around Jerusalem. The similar *Cercis canadensis* from America also became known as the Judas tree and was first grown by Henry Compton, Bishop of London, in the gardens at Fulham Palace and by Mary, Duchess of Beaufort, nearby in Chelsea. In the green vistas of landscape gardens their bright colour made them a favourite, and in the spring of 1786 John Sibthorp and Ferdinand Bauer were delighted while travelling between Rome and Naples to see their natural habitat, 'as a screen to the olive groves and cornfields now empurpled with the flowers of Cercis'.

John Sibthorp and Ferdinand Bauer, *Flora Græca*, London, 1806–40. 453.h.4, Vol.4, f.367.

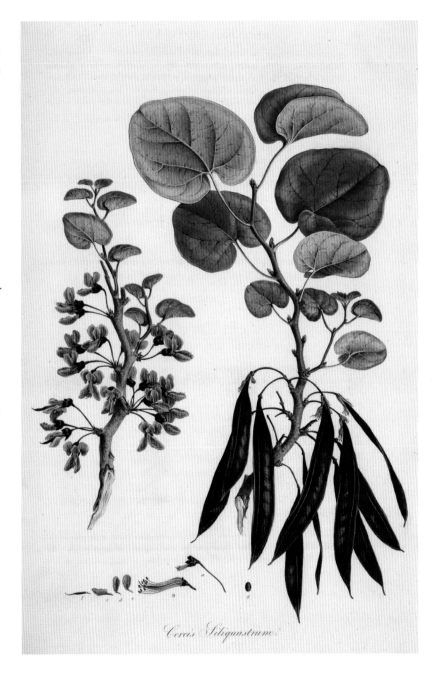

Cercis Siliquastrum

Cerinthe *(Honeywort)*

JOHN GERARD grew cerinthe in his London garden at the close of the sixteenth century, but despite being so decorative, and so popular with bees that it was named honeywort and waxflower, it has never become a familiar garden plant. Now the purple form is better known, the curving stems bearing buds that shift between blue and red as they open, providing an exotic version of related plants like comfrey. But in Mediterranean countries the cream and yellow variety is more common, and this provided Bauer's illustration for Sibthorp's *Flora Graeca*.

Above: *The Botanical Magazine*, W. Curtis London, 1787–1801. 678.c.5, Vols. 9–10, f.333.

Right: John Sibthorp and Ferdinand Bauer, *Flora Græca*, London, 1806–40. 453.h.2, Vol. 2, f.170.

Chimonanthus *(Wintersweet)*

N.º 466

AT CROOME COURT in Worcestershire the Earl of Coventry commissioned Capability Brown to transform his garden into landscape, and in the 1760s Robert Adam designed a series of follies together with an orangery because the Earl was a plantsman and needed to house his exotics in style. He was the first to grow *Chimonanthus praecox*, which he received from China in 1766. The plant is related to the American calycanthus, and aptly named wintersweet for the fragrance it wafts into the cold air of January. Chimonanthus proved hardy, and by the end of the century, when it was illustrated in the *Botanical Magazine*, the Earl had supplied stock to several London nurseries.

The Botanical Magazine, W. Curtis London, 1787–1801. 678.c.7, Vols. 13–14, f.466.

Chrysanthemum

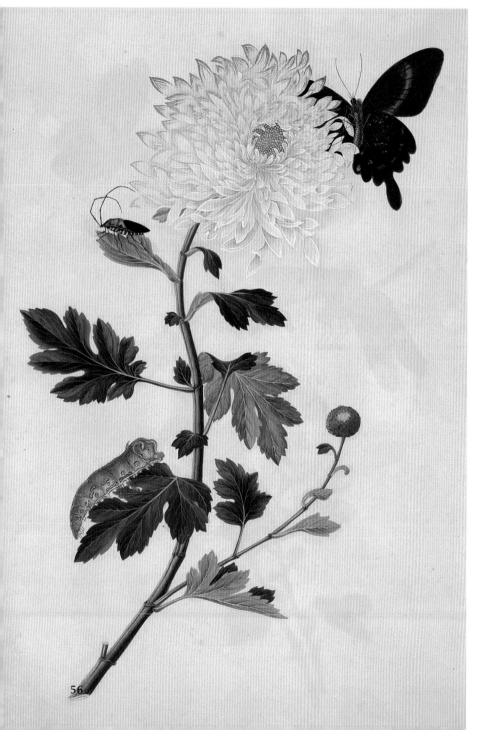

CHRYSANTHEMUMS began as yellow daisies and were converted by two thousand years of Chinese and Japanese cultivation into flowers of many shapes and sizes and of great status. The first wild chrysanthemums to arrive in Holland in the 1680s were less than impressive, but a century later plants cultivated in the nurseries of Canton became available to the merchants working in the trading stations there, offering flowers as luxurious as the examples seen on Chinese wallpaper or in albums of Chinese flower paintings. By 1790 the arrival of chrysanthemums was recorded in France and England, where they were first propagated for sale by Mr Colville, a nurseryman of Chelsea.

Canton Album, NHD 43, f.104.

Clematis

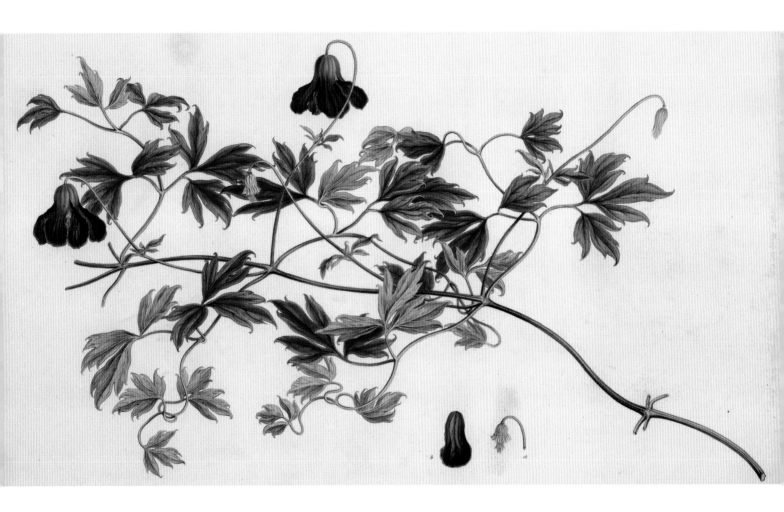

CLEMATIS VITICELLA was the first species of clematis to be brought into cultivation in Europe, during the sixteenth century, to adorn the garden arbours characteristic of the period. By the time John Sibthorp set out for the Mediterranean to discover its native habitat, various shades of red and purple flowers had been developed, and also a double form. During 1786, on the way to Istanbul, Sibthorp climbed Mt Olympus and there found the clematis that Ferdinand Bauer drew. Many other clematis species were discovered in America and Asia but *C. viticella* retained its importance – for its own charm, as a parent of new hybrids and as rootstock for grafting less vigorous new breeds.

John Sibthorp and Ferdinand Bauer, *Flora Græca*, London, 1806–40. 453.h.6, Vol. 6, f.516.

Cornus *(Dogwood)*

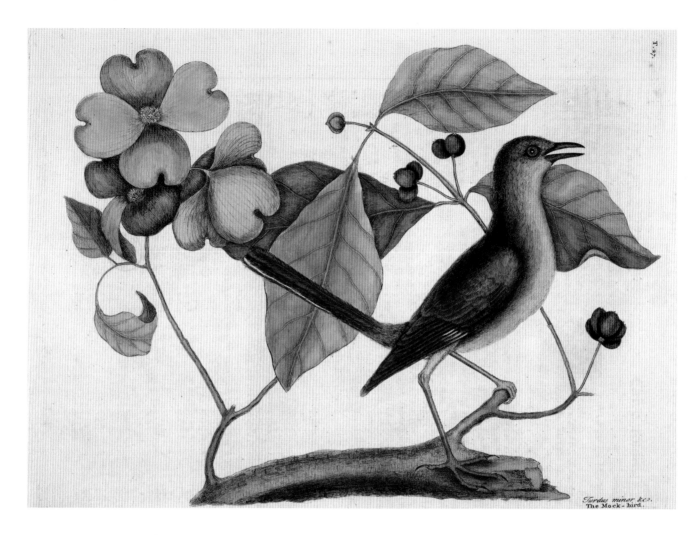

THE AMERICAN dogwoods are admired for the large bracts which surround the small clusters of real flowers. Although the most characteristic colour for the bracts is greenish white, Mark Catesby illustrated the pink form, explaining 'In Virginia I found one of these dogwood trees with flowers of a rose colour, which was luckily blown down and many of the branches had taken root, which I transplanted into a garden'. Subsequently it was the pink variety which proved readier to flower in England – first recorded in May 1761 when Peter Collinson received an urgent invitation from Enfield to come and dine with Dr Robert Uvedale, the master of the grammar school there, and see *Cornus florida* in flower.

Mark Catesby, *The Natural History of Carolina, Florida and the Bahama Islands*, London, 1754. 44.k.7, Vol. 1, f.27.

Crinum

CRINUM, being from tropical Asia, arrived in Europe later than the similar South Africa amaryllis. From Calcutta William Roxburgh sent *Crinum asiaticum*, originally from the East Indies, to Joseph Banks and his friend Charles Greville, while Thomas Hardwicke had it painted in situ. Hardwicke arrived in India in 1777 aged 22 as a soldier in the East India Company army, and travelled extensively during his military career. While rising to the rank of major general he amassed zoological specimens and drawings by Indian artists, which on his return home in 1823 he displayed in Lambeth like the Tradescants before him. He also became an influential member of the Royal Society and other scientific societies.

Thomas Hardwicke, *Collection of Indian Flower Paintings*. Add. Ms. 11011, f.34.

Curcuma *(Turmeric)*

FROM the *Zingiberaceae* family came some of the most important spices of the East – the roots of ginger, which gives the family its name, and turmeric, as well as the seeds of cardamom and amomum. All provide flavours vital to curries, pickles and chutneys, and were also important locally for dyes, medicines and ritual use. In India Roxburgh noted how the powdered root of turmeric was 'copiously thrown about during the hollee or hindu holidays' and that 'all species are of uncommon beauty'. Of cardamom Roxburgh wrote 'it yields the government up to 30,000 rupees a year', but when he investigated its cultivation he was simply told it sprang up wherever a tree had been felled.

William Roxburgh, *Plants of the Coast of Coromandel*, London, 1795–1819. 10.Tab.34, Vol. 3, f.201.

Cymbidium

CONFUCIUS considered
cymbidiums the most fragrant of
all plants, and many Chinese poets
described bronze incense burners
perfuming the air with their scent as
concubines danced. A variant story
claimed the barren wife of an emperor
became miraculously fertile when a
white cymbidium was placed in her
room, suggesting their scent was no
ordinary aphrodisiac. Linnaeus named
them epidendrum because they grow
in the hollows of trees. Possibly he
received a plant from Pehr Osbeck,
his pupil, who became a missionary
botanist in Canton, although it was
not until 1789 that a cymbidium
reached Kew – from Conrad Loddiges,
whose nursery in Hackney specialized
in tropical orchids.

Canton Album, NHD 43, f.108.

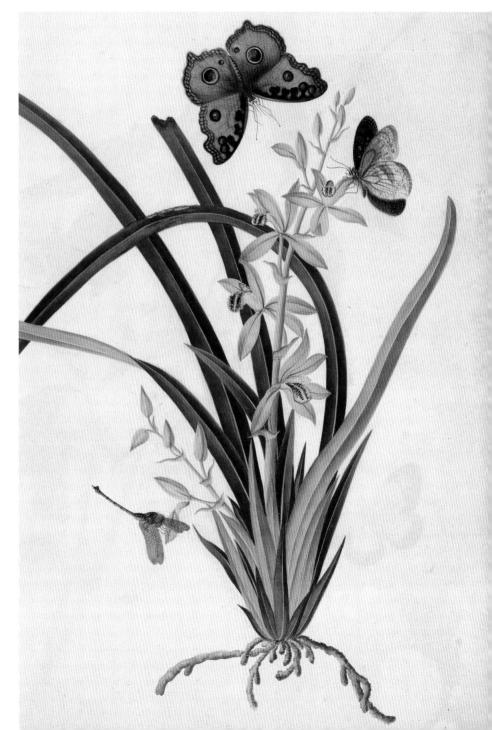

Cypripedium *(Slipper orchid)*

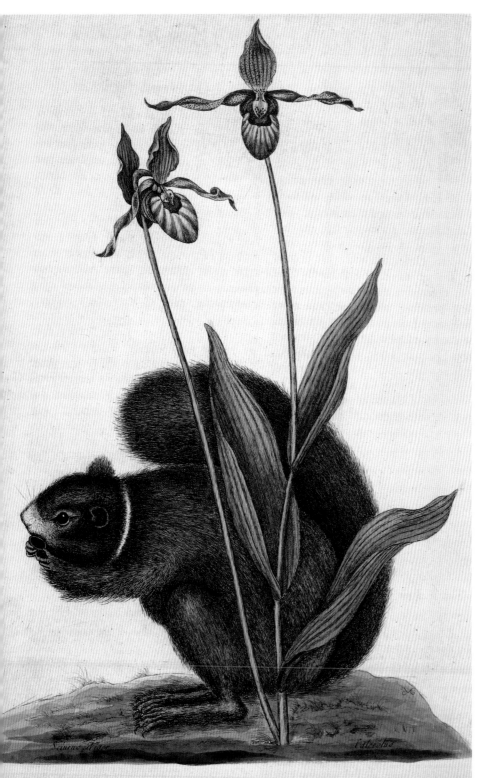

WHEN SLIPPER ORCHIDS were first discovered growing in North America they already had a name – originally Our Lady's slipper – because there are rare European orchids with the same pouched lower petal. It is designed for insects to enter in search of sweetness, fertilizing successive flowers in the process. The Latin name, meaning 'Cypriot's shoe', suggested the slipper belonged to Venus (who was born from a wave in Cyprus). Mark Catesby saw these yellow slipper orchids, with twisted side petals, growing 'on sandy river banks in Carolina, Virginia and Pennsylvania', and Philip Miller listed them in the appendix of his 1731 *Gardener's Dictionary*, when they had only just been introduced.

Mark Catesby, *The Natural History of Carolina, Florida and the Bahama Islands*, London, 1754. 44.k.8, Vol. 2, f.73.

Datura *(Thorn apple, Angel's trumpet)*

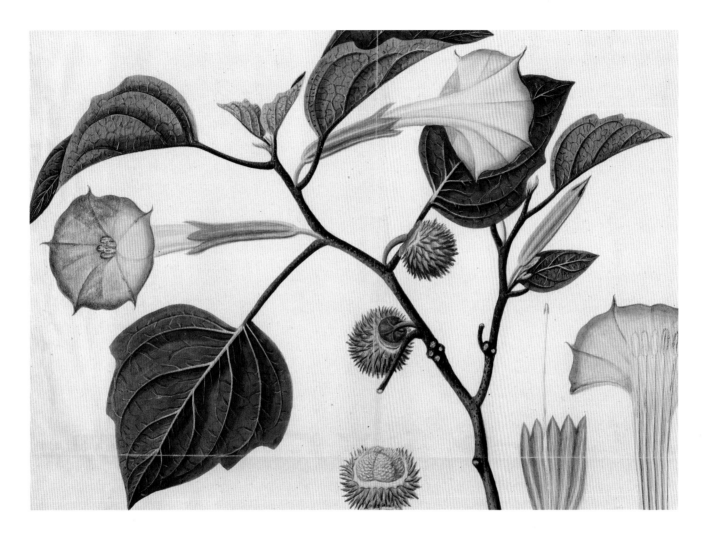

EXOTIC DATURAS and related species (some, such as brugmansia, as large as trees) became known in Europe primarily from America, where the native Indians revered their hallucinogenic properties. But datura also occurs in Asia, including Indonesia, where Pieter de Ruyter illustrated it to accompany the great *Herbarium Amboinense*, the life's work of the blind botanist G.E. Rumf. The name datura derives from Sanskrit, being transmitted by Arab physicians. The thorn apple *Datura stramonium* was the first species of datura to reach Europe. Now datura is a prevalent weed in America, known as Jamestown or Jimson weed, but rather than being native it may have arrived as seeds in the earth used for ships' ballast.

Pieter de Ruyter, *Plants of Amboina*, 1692. Add. Ms. 11027, f.10.

Dianthus *(Pinks and carnations)*

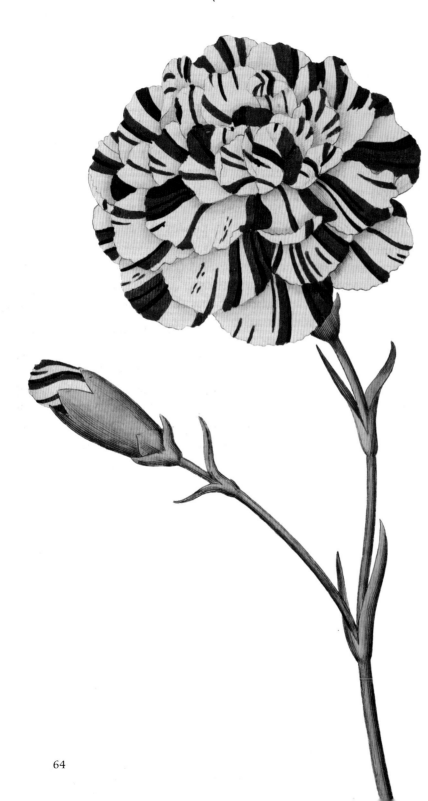

THE *BOTANICAL MAGAZINE* for 1787 featured a new carnation called Franklin's Tartar – while noting ruefully that such highly developed varieties were liable to be ephemeral – and mentioned wild pinks grew in the walls of Rochester Castle. Meanwhile John Sibthorp, plant hunting for *Flora Graeca*, rediscovered the wild Mediterranean pinks, which the Greek herbalists had originally named dianthus, meaning flower of the gods. In 1716 in his plant nursery in Hoxton Thomas Fairchild experimented with crossing a double carnation with a sweet william, and produced Fairchild's Mule, with a cluster of tiny double flowers. The Royal Society invited Fairchild to deliver a paper on his achievement but, fearful that he had tampered with the divine order, he decided instead to endow an annual sermon on the wonders of God's creation, to be preached in a City church.

Left: *The Botanical Magazine*, W. Curtis London, 1787–1801. 678.c.1, Vols. 1–2, f.39.

Opposite: John Sibthorp and Ferdinand Bauer, *Flora Græca*, London, 1806–40. 453.h.4, Vol. 4, f.395.

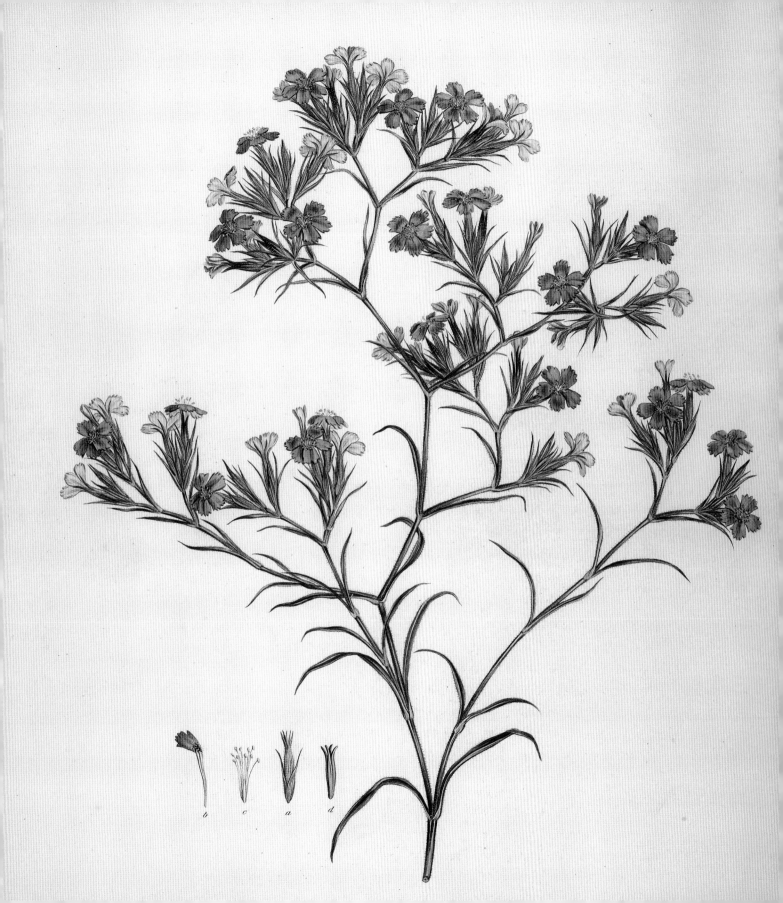

Digitalis *(Foxglove)*

THE PURPLE FOXGLOVE was treated with superstitious caution until Dr William Wittering of Birmingham published *The Account of the Foxglove* in 1785, investigating how digitalin stimulated the kidneys and – more importantly – regulated the heart. Meanwhile other species of foxglove, more fascinating than important, were discovered. The Duchess of Beaufort first received seeds of *Digitalis canariensis* from the Canary Islands in 1698, possibly via Commelin in Amsterdam, and it was reintroduced when Francis Masson collected seed in the Canaries during Captain Cook's second *Endeavour* voyage in 1772. The rusty-coloured *D. ferruginea* shown here was found on the slopes of Mt Parnassus in 1786 by Sibthorp and Ferdinand Bauer.

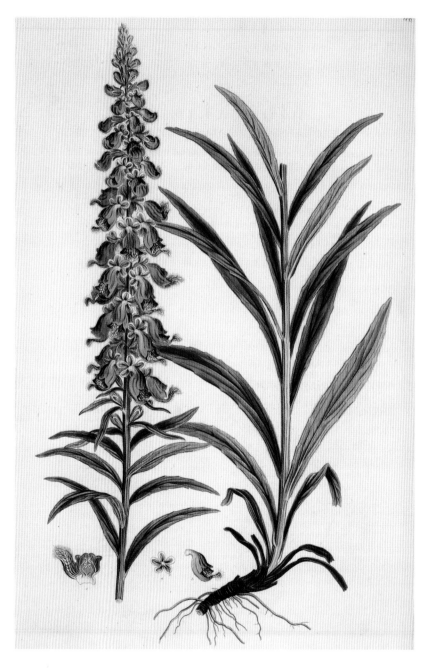

John Sibthorp and Ferdinand Bauer, *Flora Græca*, London, 1806–40. 453.h.7, Vol. 7, f.606.

Dillenia

DILLENIA, an Indo-Malaysian plant, is valued chiefly for its cheerful, long-lasting flowers. First appearing in *Herbarium Amboinense* in 1692, a hundred years later the *Botanical Magazine* described it as growing 'for many years at Kew and in the stoves of the curious near town'. It was named in honour of J.J. Dillenius, the first Professor of Botany at Oxford, and one of those with whom Linnaeus had to contend in establishing his classification systems. On Linnaeus's first visit in 1736 Dillenius introduced him as 'the man who has thrown all botany into confusion'; and in 1753, when Linnaeus's *Species Plantarum* established the binomial system of naming plants, Dillenius felt, like many others, that Linnaeus had gone too far in overturning existing nomenclature.

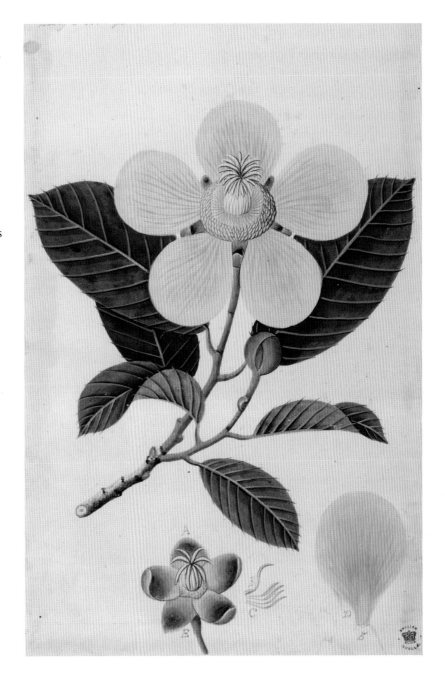

Pieter de Ruyter, *Plants of Amboina*, 1692.
Add. Ms. 11027, f.83.

Dodecatheon *(Shooting star, American cowslip)*

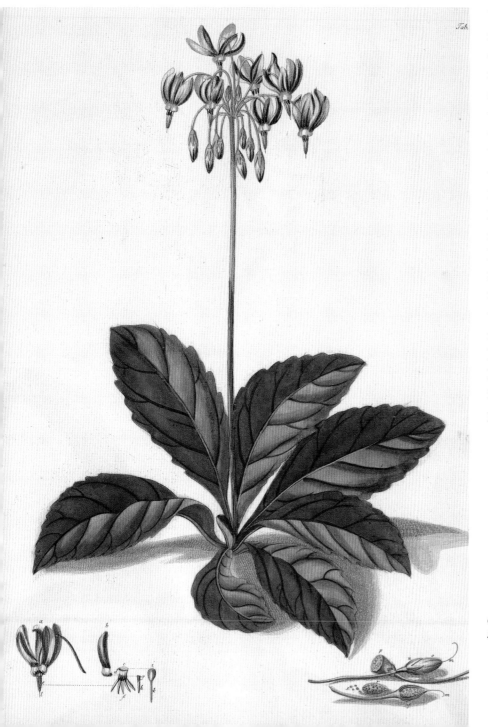

THE AMERICAN COWSLIP
is midway between primulas and
cyclamen, to both of which it is
related, and Linnaeus endowed it with
a classical name meaning flower of
the twelve gods. Seeds of dodecatheon
were sent to Bishop Henry Compton
by John Banister, the chaplain to
the American colonies who shared
his bishop's enthusiasm for plants.
Banister's botanical discoveries
in America lasted from 1678 until
his untimely death (plant hunting)
in 1692. And the dodecatheon he
introduced died out after 1713 when
the new Bishop of London failed to
nurture the collections at Fulham
Palace. It was reintroduced when John
Bartram sent seeds to Peter Collinson
in 1745, and was soon available in
plant nurseries.

Christoph Jacob Trew and Georg Ehret, *Plantæ
Selectæ*, Nuremberg, 1750–90. 36.i.10, f.12.

Eichhornia *(Water hyacinth)*

THIS NATIVE of tropical America was introduced into Asia perhaps as an ornamental, perhaps because the enormous rafts of green matter it produces can form the foundations of floating market gardens, free of the irrigation problems assailing hot countries. Its beauty was emphasized by the flair of the Indian artist employed by the naturalist Thomas Hardwicke – who wrote an accompanying note that it 'grew in all the ditches about Calcutta'. That its introduction was a mistake became evident as it turned into an invasive weed choking tropical waterways. Water hyacinths spread rapidly through a process of vegetative budding (instead of seeds), enabling two parent plants to produce over a thousand offspring within months.

Thomas Hardwicke, *Collection of Indian Flower Paintings*. Add. Ms. 11011, f.13.

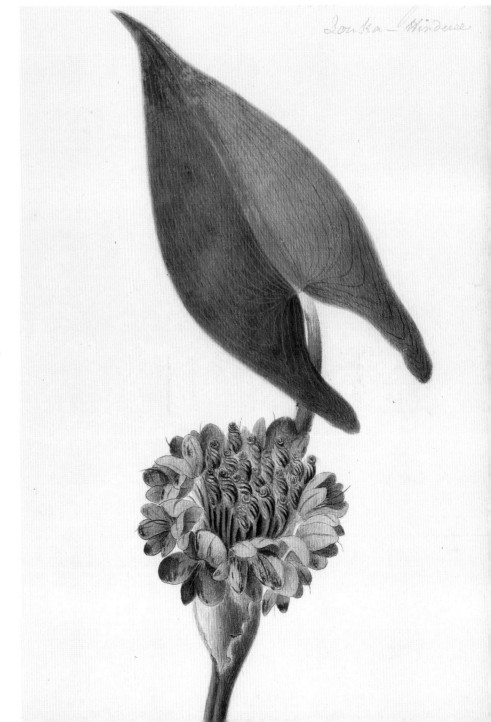

Erica *(Heather)*

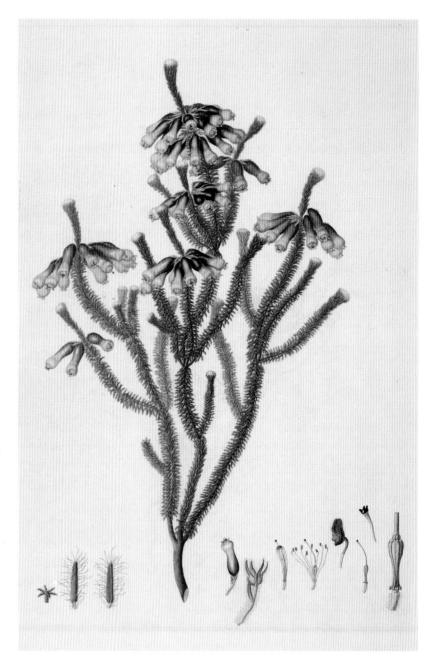

FRANCIS BAUER began his career as a botanical illustrator, like his more adventurous brother Ferdinand, working in Vienna for Nikolaus Jacquin, but on a visit to London in 1788 he was hired by Joseph Banks to become a resident botanical artist at Kew. There he worked tranquilly for the next fifty years, but his published plates were few and a grand work entitled *Delineations of the Exotic Plants at Kew* consisted merely of thirty heathers from South Africa. Given the minute detail of Bauer's illustrations, it is not surprising he got no further. Ericas arrived from Francis Masson in the Cape, and were disseminated by Lee's nursery in Hammersmith, enjoying a great vogue.

Above, right and opposite: Franz [Francis] Andrea Bauer, *Delineations of Exotick Plants Cultivated in the Royal Garden at Kew*, London, 1796. Left to right: 10.Tab.32, f.24, f.20 and f.10.

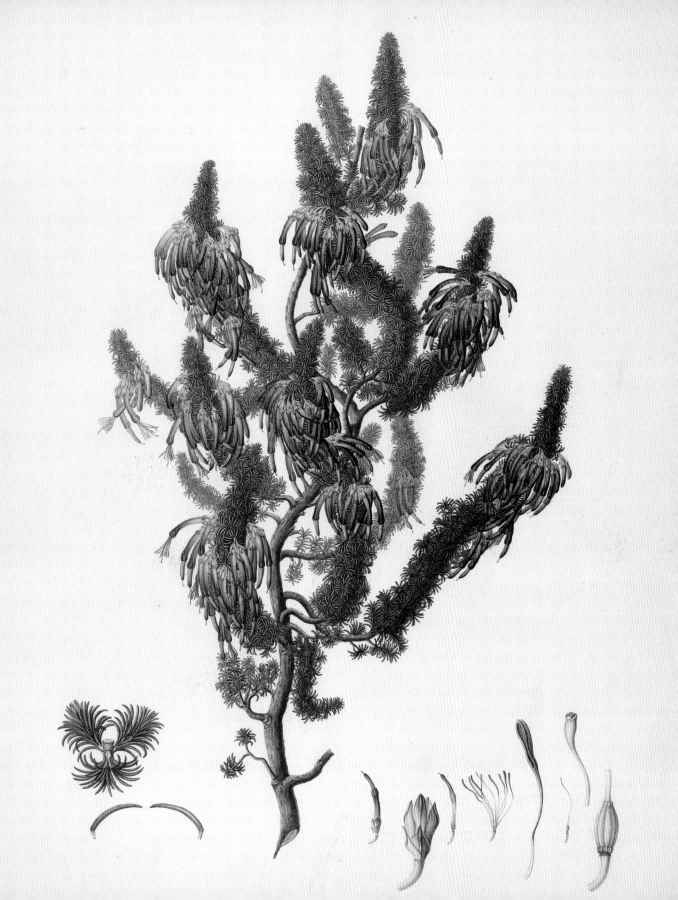

Erythrina *(Coral tree)*

THE AMAZING FLOWERS of erythrina species were encountered by European botanical explorers in both America and Asia. Mark Catesby, Maria Sibylla Merian and Pieter de Ruyter all produced dramatic images, but none equalled the anonymous Indian artist working in Calcutta on the natural history drawings commissioned by Marquess Wellesley, the Governor of India from 1797 to 1805. Erythrina flowers are adapted for pollination by birds, which sometimes emerge dripping with nectar. Primarily the trees are cultivated for ornament and shade, but the flowers are edible, the gums yield pigment, and the seeds make tempting beads.

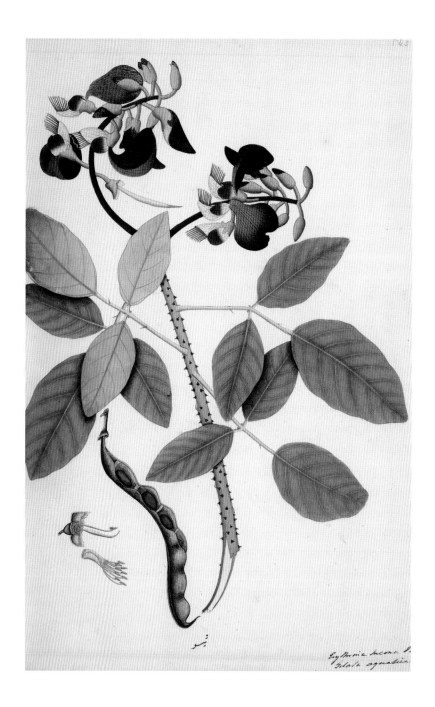

Wellesley Collection, *Natural History Drawings*. NHD 19, f.45.

Eucalyptus *(Gum tree)*

AUSTRALIA has over four hundred species of eucalyptus, greatly varied in size and shape (gum trees, bloodwoods, boxes, peppermints, stringybarks and ironbarks) but always distinctive from other trees and giving the landscape a unique character. Their barks offer a magical range of textures and colours, their fluffy flowers have a strange beauty, and their defining characteristic is the lid that keeps the bud closed until ready for fertilization – hence the name eucalypt, meaning covered over. *Eucalyptus robusta* was one of the first to be listed in *Hortus Kewensis* (the record of plants introduced into Kew Gardens) and J.E. Smith called it the New Holland mahogany – eucalypts proved important and fast-growing timber trees and were transported in great quantity especially to California, Portugal and East Africa.

James Edward Smith and James Sowerby, *A Specimen of the Botany of New Holland*, London, 1793. 443.g.29, Plate XIII.

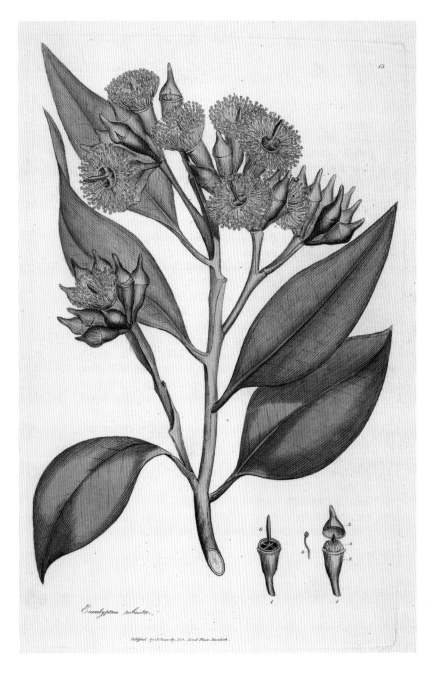

Eucalyptus robusta.

Eucomis *(Pineapple flower)*

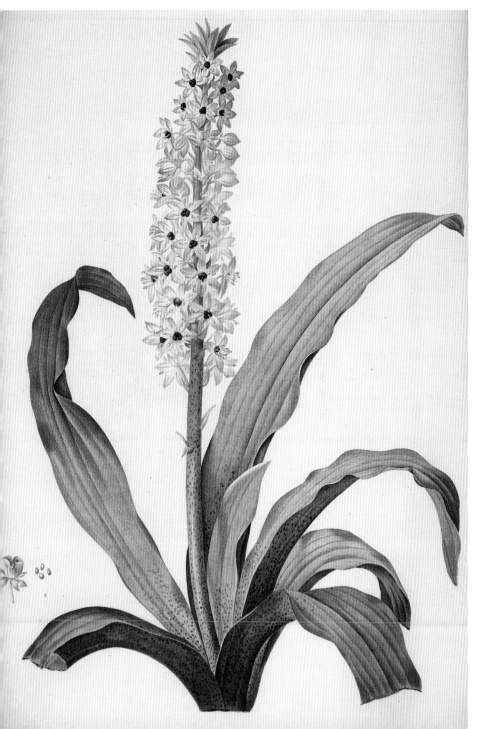

EUCOMIS was introduced from South Africa early in the eighteenth century and Linnaeus endowed it with a name derived from the Greek words meaning 'beautiful head'. The most ornamental species were *Eucomis autumnalis*, which arrived in 1760; and *E.comosa*, sent to Kew by Francis Masson in 1790. Although they are lilies, their popular name was pineapple flower on account of the clustered, waxy flowerhead topped by a tuft of leafy bracts. This association gave eucomis an extra cachet in an age when pineapples were considered the classiest of fruits, adorning the tables of the wealthy. Pineapples also inspired an outburst of architectural finials that signified fine hospitality and warm welcome.

Pierre Joseph Redoute, *Les Liliacées*, Paris, 1802–16. 455.h.11, Vol. 4, f.208.

Euphorbia

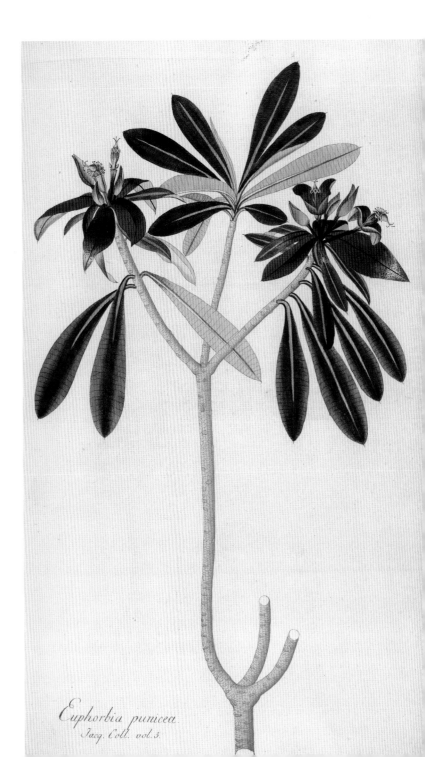

THE SHOWIEST euphorbias come from warm climates and include *Euphorbia pulcherrima* (poinsettia from Mexico) with its red bracts, and also spiney succulents that provide the African equivalents of cacti. Europeans were only familiar with green-flowered spurges, with stems containing milky latex, which featured in medical herbals because anything that purged bad humours was considered efficacious. In *Flora Graeca* Ferdinand Bauer illustrated many euphorbias – from the tree-sized *E. dendroides*, which grows down rocky slopes overlooking Mediterranean seascapes, to the low-growing *E. myrsinites*. Euphorbia flowers consist of whorls of green bracts, each containing several tiny male flowers around a central, round-bodied female, and four horn-shaped glands enclosing them like the jewelled setting of a brooch.

Above: John Sibthorp and Ferdinand Bauer, *Flora Græca*, London, 1806–40. 453.h.5, Vol. 5, f.471.

Right: Nikolaus Joseph Jacquin, *Icones plantarum rariorum*, Vienna, 1781–93. 34.h.5, Vol. 3, f.484.

Euphorbia punicea.
Jacq. Coll. vol. 3.

Fritillaria *(Crown imperial and snakeshead fritillary)*

ALTHOUGH the crown imperial, *Fritillaria imperialis* (see p.19), was the showiest fritillary introduced into European gardens in the seventeenth century, the plate from the 1608 *Velins du Roi* proves that other species were in cultivation, including two forms of the purple/brown *F. pyrenaica* from Spain and the yellow *F. latifolia* from Turkey. The snakeshead fritillary, *F. meleagris* (here named *Fritillaria Vulgaris*) is native to northern Europe. Still-life paintings often featured its chequered purple flowers drooping beneath gaudy tulips in a sinister little allegory of life and death. Local names included death bell, lazarus bell and leopard's (originally leper's) lily. A sense of chance, if not doom, was also reflected in the name fritillary, likening the shape of the flowers to a dice box – *fritillus* in Latin.

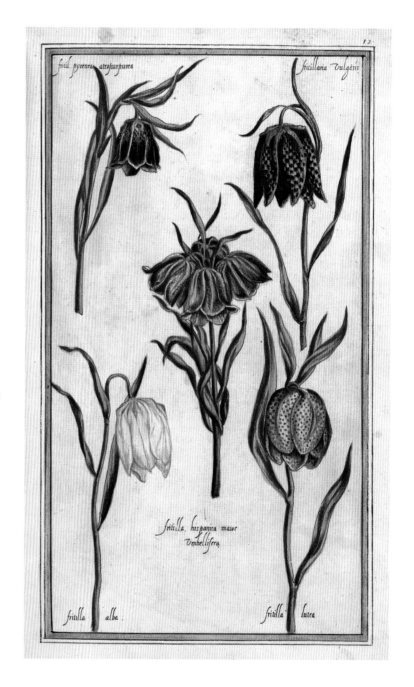

Pierre Vallet, *Velins du Roi*, Paris, 1623. 35.g.3, f.12.

Fuchsia

THE FIRST FUCHSIA was discovered in San Domingo by Charles Plumier, the French priest whose pioneering studies of American plants were published in 1703. In 1719 another French missionary discovered in Chile *Fuchsia magellanica*, the dominant ancestor of modern fuchsias, followed by *F. coccinea* from Brazil. Propagation took off in the 1790s, due to the skill with cuttings of the nurseryman James Lee of Hammersmith, who claimed to have spotted his finest specimen on the windowsill of a sailor's wife in Wapping. Society flocked to Lee's nursery and the *Botanical Magazine* confirmed the fashion for fuchsias, adding, 'They produce their pendant blossoms throughout most of the summer, and the inner petals resemble a small roll of the richest purple ribbon.'

The Botanical Magazine, W. Curtis London, 1787–1801. 678.c.2, Vols. 3–4, f.97.

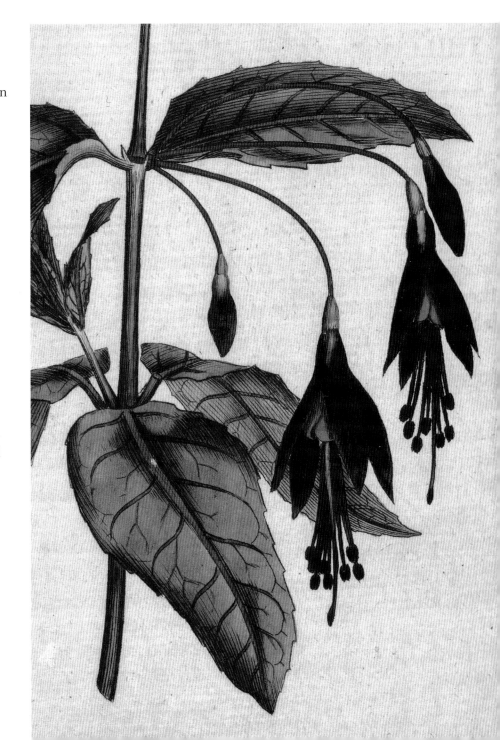

Gardenia

DUTCH BOTANISTS in the East Indies had encountered the large, scented flowers of gardenia before its naming caused a major dispute. When it arrived in England in 1754 Philip Miller identified it as a jasmine. His old antagonist John Ellis (a botanist who specialized in methods of introducing live plants from overseas) was sure it was a new genus and wrote suggesting that Linnaeus name it after Alexander Garden, a doctor in Carolina who was one of his chief botanical contacts. Linnaeus demurred. Meanwhile the desirable new plant had been propagated by James Gordon of Mile End nursery, at enormous profit. When Linnaeus received his own plant – worth six guineas – together with a letter in support of naming it gardenia, he relented.

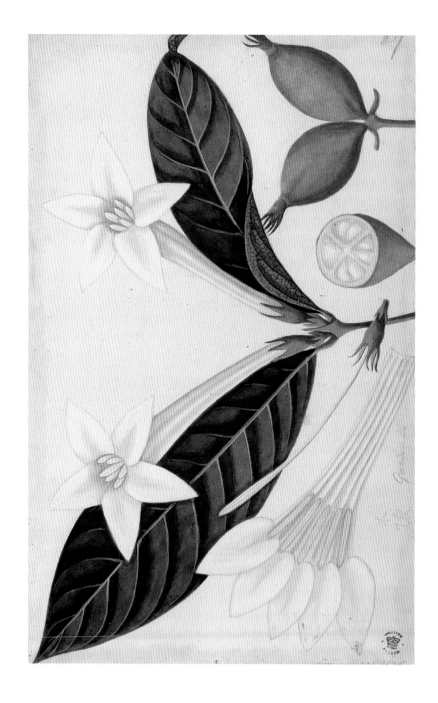

Pieter de Ruyter, *Plants of Amboina*, 1692.
Add. Ms. 11027, f.27.

Gladiolus

THE WILD, pink gladioli of Europe first gave
the genus its name because of their sword-shaped
leaves. In 1620 when the elder John Tradescant
joined an expedition against the Barbary pirates
of North Africa, he was enchanted by whole acres
of the brilliant 'corn flagge of Constantinople' (the
silky, magenta *Gladiolus byzantinus*). But the South
African gladioli overshadowed these, and became
the ancestors of the garden hybrids. In 1660 Thomas
Hanmer in his *Garden Book* described a rarity from
the Cape with 'light red towards scarlet flowers'.
In 1745 Philip Miller grew the sweetly scented *G.
tristis* in the Chelsea Physic Garden, after which
nurserymen such as Lee of Hammersmith sought
out new species to tempt customers. One of the
finest collections was held in the Schonbrunn
gardens in Vienna, where over forty were illustrated
in Jacquin's *Icones Plantarum Rariorum*.

Nikolaus Joseph Jacquin, *Icones plantarum
rariorum*, Vienna, 1781–93. 34.h.5, Vol. 2, f.244.

Gladioli tristis varietas.

Glaucium *(Horned poppy)*

THE HORNED POPPIES that John Sibthorp found during his travels in the Greek islands – notably Rhodes – and Turkey were so called because they bore their seeds in long 'horned' pods, unlike the lidded capsules of most poppies. Their counterparts, *Glaucium flavum*, the horned sea poppies that grow on shingle and sand dunes in northern Europe, have soft yellow petals. In England they were called bruise root or squatmore because, in the words of John Aubrey the antiquary and writer, they were 'of wonderful effect for bruises'. The oriental horned poppies – being clothed in silky Byzantine scarlet, purple and orange – were named as a separate species, *G. phoeniceum*.

John Sibthorp and Ferdinand Bauer, *Flora Græca*, London, 1806–40. 453.h.5, Vol. 5, f.489.

Gloriosa *(Flame lily)*

THIS CLIMBING LILY from the Asian tropics reached Commelin's physic garden in Amsterdam bearing the title *Lilium zeylanicum superbum*, meaning it was brought from Ceylon. As a new rarity it also entered the collection of William and Mary at Hampton Court, where it struggled in an ornate pot. The appreciative Latin name *gloriosa* was confirmed by Linnaeus, but its beauty had a darker side because the highly poisonous roots were used to commit suicide. In 1796 Thomas Hardwicke, who was by then a captain in the Indian army, had it illustrated flourishing in its native tropics. Ultimately Hardwicke's collection of natural history drawings totalled 4500 and was bequeathed to the nation.

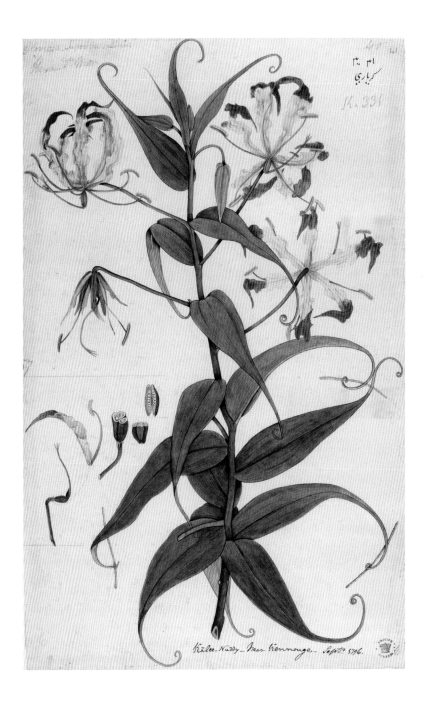

Thomas Hardwicke, *Collection of Indian Flower Paintings*. Add. Ms.11011, f.41.

Gossypium *(Cotton)*

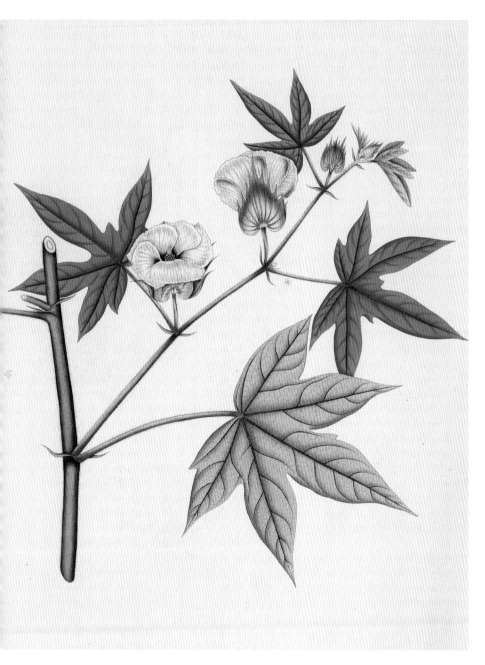

WILLIAM ROXBURGH'S
scientific interest focused on Indian
cotton, which was ripe for further
development, especially 'the exceeding
fine cotton for the delicate and
beautiful muslins' that by the 1780s
were becoming the height of European
fashion. Roxburgh believed the local
variations in quality owed much
to soil conditions and cultivation
methods, rather than to spinning
techniques as the Indians claimed.
For Roxburgh local artists illustrated
the features of different varieties,
including Upland cotton, the recently
introduced China cotton, and the most
widespread Dacca cotton (seen here)
– distinguished by the reddish colour
that suffused the plant, including the
centres of the flowers, from which a
yellow dye was extracted.

William Roxburgh, *Plants of the Coast of
Coromandel*, London, 1795–1819. 10.Tab.34,
Vol. 3, f.269.

Grevillea

Embothrium sericeum.

JOSEPH BANKS named the most ornamental of his newly discovered Australian plants in honour of his friend Charles Greville, son of the Earl of Warwick and nephew of Sir William Hamilton, Ambassador to Naples (to whom Charles introduced his mistress Emma, who became Lady Hamilton and eventually Nelson's mistress). In Greville's garden near Paddington Green 'the rarest and most curious plants from various climates were cultivated with peculiar success', according to the leading botanist J.E. Smith. Greville was a member of the Royal Society and a founder of the Horticultural Society, but even more notable as a collector of minerals than of plants, endowing the nation with his geological collection.

James Edward Smith & James Sowerby, *A Specimen of the Botany of New Holland*, London, 1793. 443.g.29, Plate IX.

Haemanthus *(Blood lily)*

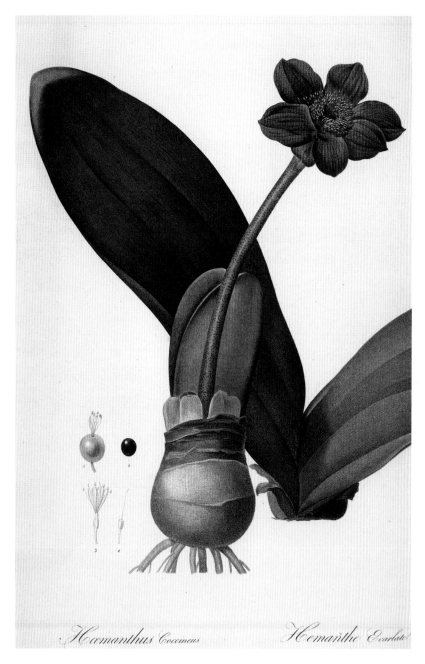

HAEMANTHUS, a complex amaryllis from the Cape, was first cultivated in Paris early in the seventeenth century by Henry IV's royal gardener Jean Robin. He named it *Satyrium guinea*, a name that echoed the confusions of the time. *Satyrium* was a label generally applied to orchids and arums, which were believed to have aphrodisiac roots, and the geographical term Guinea usually signified West Africa. In 1694, in *Elements de botanique*, Joseph Pitton de Tournefort, Professor of Botany in the Jardin du Roi in the reign of Louis XIV, named it haemanthus, on account of its blood-red colour. He then departed on his famous voyage to the Levant where, under cover of botanizing, he was suspected of spying on Turkish fortifications.

Hæmanthus Coccineus *Hœmanthe Écarlate*

Left: Pierre Joseph Redoute, *Les Liliacées*, Paris, 1802–16. 37.i.8, f.39.

Opposite: Christoph Jacob Trew and Georg Ehret, *Plantæ Selectæ*, Nuremberg, 1750–90. 36.i.10, f.44.

Tab. XLIV.

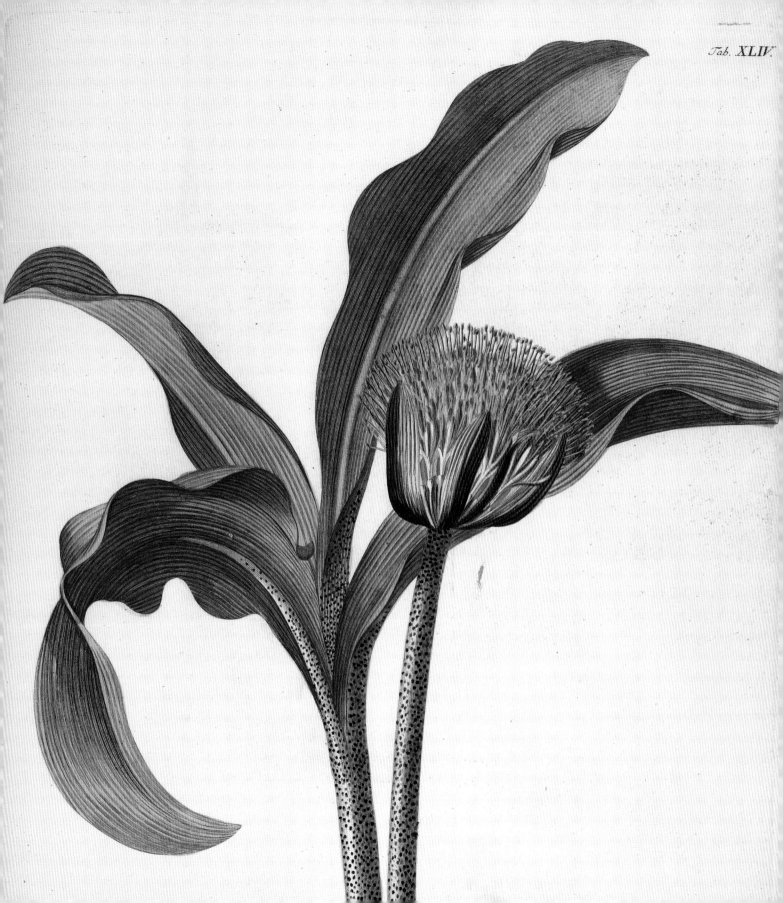

Hamamelis *(Witch hazel)*

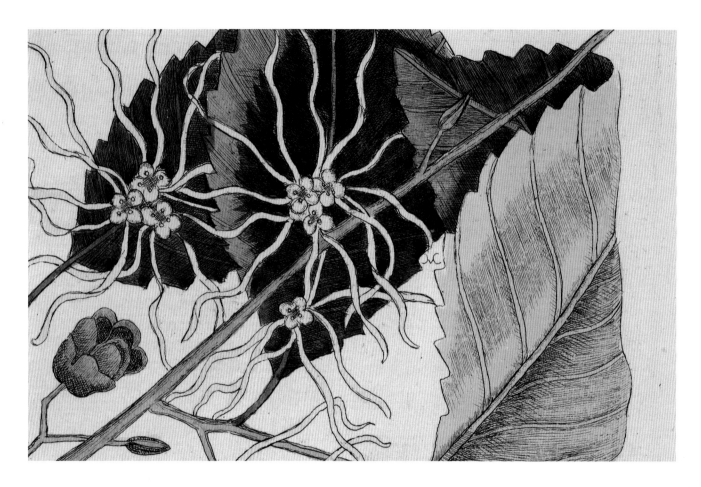

THE FIRST HAMAMELIS, *Hamamelis virginiana*, arrived in Europe from North America but was later superseded by the showier oriental species, especially *H. mollis*. Mark Catesby, who had seen *H. virginiana* growing 'like nut trees with pale yellow flowers' in Carolina, received a young tree in 1743 – 'sent me in a case of earth from Virginia. It arrived at Christmas full of blossoms and has flowered annually ever since'. Catesby's illustration of hamamelis was later published in 'a collection of 85 curious trees of north America adapted to the soil and climate of Great Britain'. The inhabitants of America valued it for treating burns, bruises and inflammation, and under the name of witch hazel it became a popular household remedy.

Mark Catesby, *Hortus Europæ Americanus*, London, 1767. 452.f.14, f.57.

Hedychium *(Ginger lily)*

THE ASIATIC members of the ginger family, which have been valued above all as spices, also have beautiful and heavily scented flowers. The ginger lily of the Indomalaysia region, despite its family resemblance to ginger, turmeric and cardomum, lacks their culinary appeal and the rhizome was used instead in perfumery. Its extraordinary flowers appeared in Europe for the first time among the natural history drawings by Indian artists which were assembled by Thomas Hardwicke while he served in the East India Company army. Several species of birds, fish, reptiles and bats commemorate his discoveries; and, although no plants were named after him, he was an enthusiastic correspondent of Joseph Banks, and a shining example of the enthusiastic amateurs on whom botany relied.

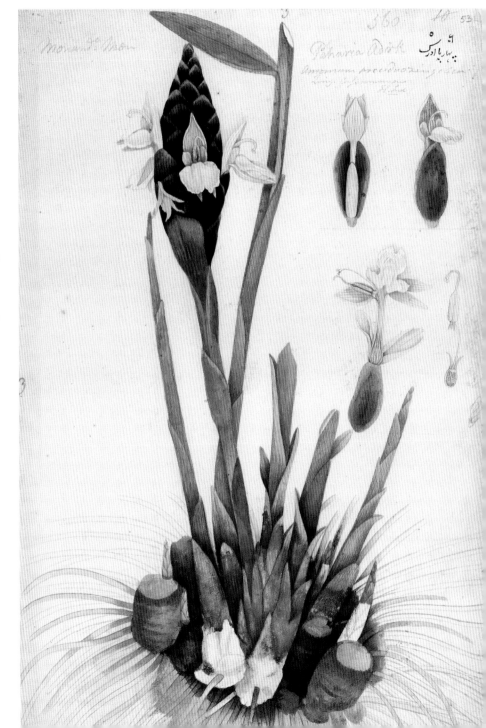

Thomas Hardwicke, *Collection of Indian Flower Paintings*. Add. Ms.11011, f.53.

Heliconia *(Lobster claw)*

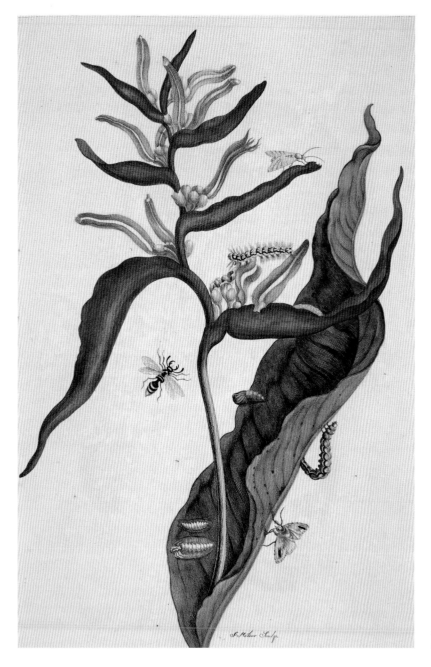

HELICONIA, which is native to tropical America, is related to both bananas and ginger, and rivals them for extraordinary displays of long-lasting flowers. Maria Sibylla Merian encountered heliconia while living in the Dutch colony of Surinam, where she travelled to study the metamorphosis of insects and their relationships with plants. Merian moved in scientific as well as artistic circles, where natural history collections from warmer climes were all the rage. She resolved to study these phenomena from living specimens in a tropical situation, and in 1699 set off for Surinam, where the religious order to which she belonged owned a plantation in which she could live, study and paint.

Maria Sibylla Merian, *Metamorphosis insectorum Surinamensium*, Amsterdam, 1705. 649.c.26, f.54.

Helleborus *(Christmas or Lenten rose)*

HELLEBORES are highly poisonous, but were important at moments of crisis in traditional medicine because of their sedative action. In Europe the green-flowered hellebores were used, while in the eastern Mediterranean countries *Helleborus niger* and *H. orientalis* were better known. All hellebores have black roots (the part used in medicine), but this feature was most striking when contrasted to the pure white flowers of *H. niger*, the Christmas rose. The black hellebore of the ancient Greek herbalists was probably *H. orientalis*, the Lenten rose, which was illustrated in Sibthorp's *Flora Graeca*. Both these most decorative hellebores remained unusual in cultivation; in the 1730s they were 'scarcely to be seen unless at Mr Fairchild's in Hoxton'.

Helleborus officinalis

John Sibthorp and Ferdinand Bauer, *Flora Græca*, London, 1806–40. 453.h.6, Vol. 6, f.523.

Hermodactylus *(Snakeshead iris)*

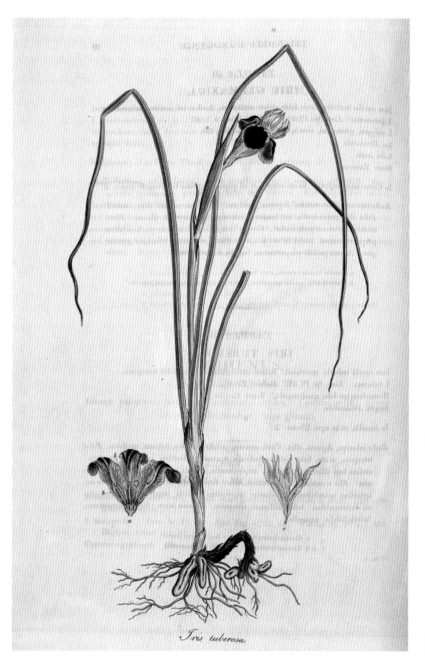

Iris tuberosa.

SINCE SIBTHORP'S original inspiration was to seek out in Greece the plants mentioned in classical works, he presumably investigated why they named this iris after the finger of Hermes. Irises traditionally symbolized links between the human and divine. Hermes was the god who led the souls of the dead to the otherworld, bearing the caduceus, his protective wand which this iris possibly resembled – the caduceus was entwined with snakes, and this plant was therefore called the snakeshead iris. When Sibthorp discovered its native habitat, hermodactylus was already known in English gardens; Gerard had described its lower petals as 'smooth and soft as black velvet' and its upper petals as 'goose turd green' – although Gerard doubted this was the true hermodactylus.

John Sibthorp and Ferdinand Bauer, *Flora Græca*, London, 1806–40. 453.h.1, Vol. 1, f.41.

Hibiscus

ALL HIBISCUS came originally from the Far East, *Hibiscus syriacus* arriving in time to be mentioned by Greek and Roman herbalists. Other Chinese species arrived during the seventeenth century, in the wake of the tea trade, and became treasured hothouse flowers. The Duchess of Beaufort owned a 'rose' from China that opened white and turned dark pink, which sounds like *H. mutabilis* (its Chinese name meant civil servant). The handsome *H. rosa-sinensis* was first grown in England by Philip Miller at the Chelsea Physic Garden, although this may have been a reintroduction – as often happened when a fragile tropical plant failed to survive after a few years in a smoky glasshouse.

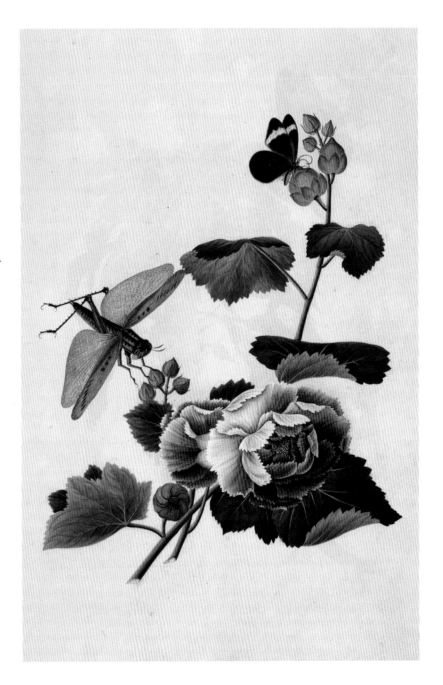

Canton Album, NHD 43, f.102.

Ipomoea *(Morning glory)*

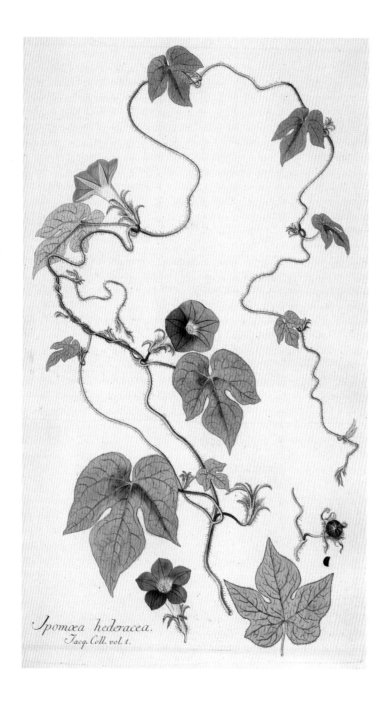

Ipomœa hederacea.
Jacq. Coll. vol. 1.

MORNING GLORIES from tropical America, so much more beautiful than European bindweed, seduced seventeenth-century painters of flower still lifes, and plantsmen such as John Parkinson, with their 'most excellent, fair, sky-coloured blue that amazeth the spectator'. The true morning glory was *Ipomoea purpurea*, with a maroon streak down each petal, while *I. tricolor* produced the 'heavenly blue' colour and also concealed hallucinogenic properties in its seeds. They were named morning glory because, by the middle of the day, the flowers became a papery twist, signifying mortality to sensitive souls. Meanwhile the sweet potato, *I. batatas*, offered a new starch crop for transportation to other tropical regions, its edible importance slyly highlighted by Maria Sibylla Merian's large grub.

Left: Nikolaus Joseph Jacquin, *Icones plantarum rariorum*, Vienna, 1781–93. 34.h.5, Vol. 1, f.36.

Opposite: Maria Sibylla Merian, *Metamorphosis insectorum Surinamensium*, Amsterdam, 1705. 649.c.26, f.50.

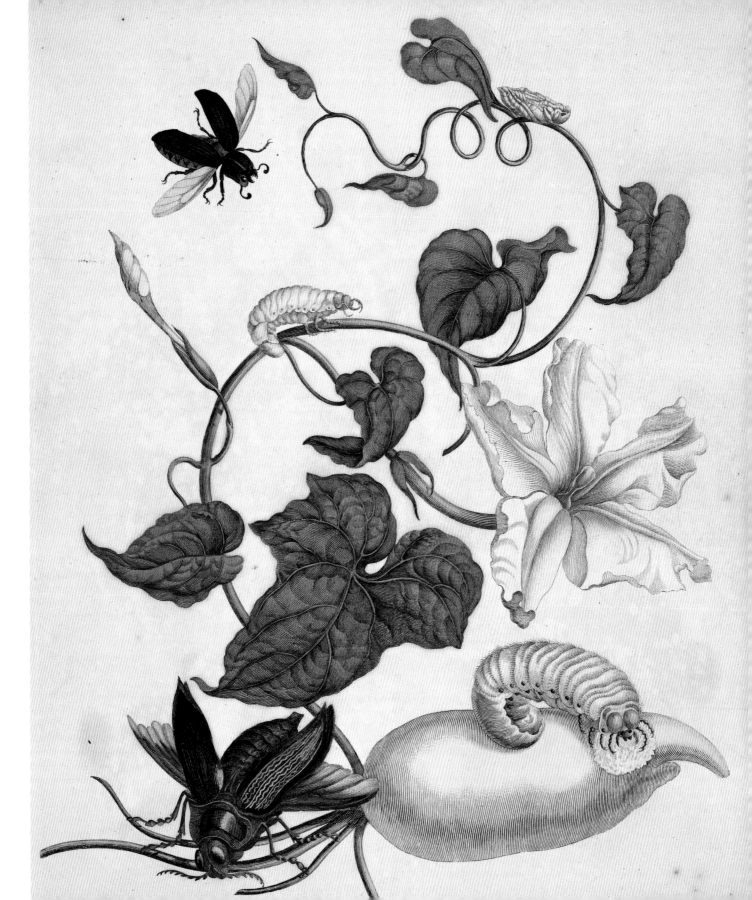

Iris

THE TRADITIONAL iris of European gardens has always been the purple flag iris, *Iris germanica*, the major ancestor of our multi-coloured bearded iris. By the seventeenth century the Middle Eastern countries were yielding up bulbous and alpine irises which offered the first glimpse of the colour variation and subtle patterning that irises could produce – but as for identifying them, in 1640 John Parkinson was already calling them 'a confused though elegant family'. Jacquin's team of botanical artists, working in Vienna, had the best access to the tiny alpine irises of Eastern Europe and Asia Minor. Further species subsequently arrived, to be illustrated in the *Botanical Magazine*.

Right: Nikolaus Joseph Jacquin, *Icones plantarum rariorum*, Vienna, 1781–93. 34.h.5, Vol. 2, f.220.

Opposite: *The Botanical Magazine*, W. Curtis London, 1787–1801. 678.c.1, Vols. 1–2, f.1.

Iris flavissima.
Jacq. Coll. vol. 4.

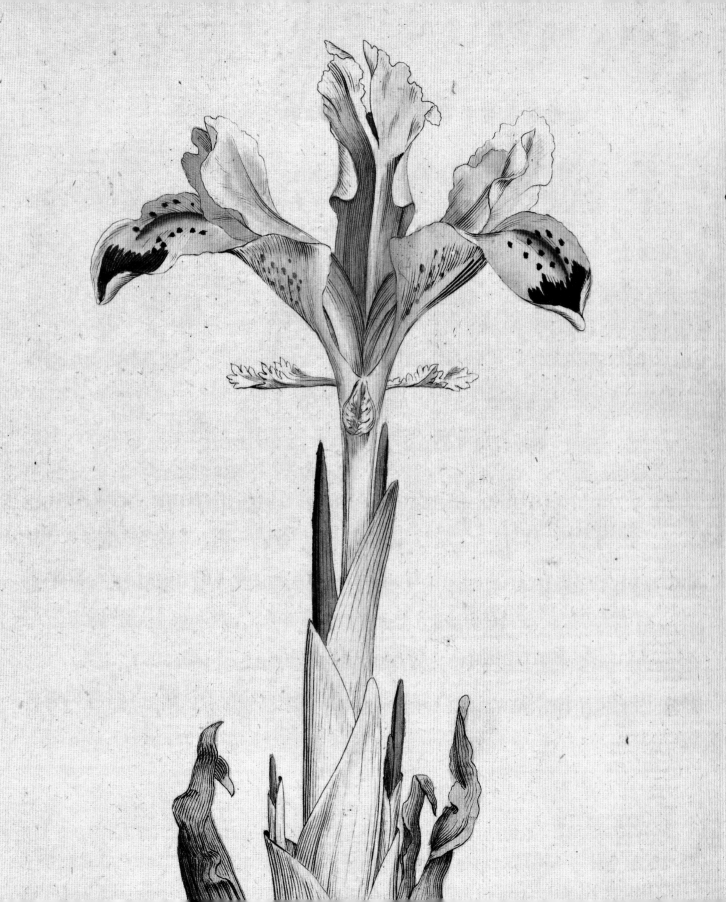

Kalmia *(Calico bush)*

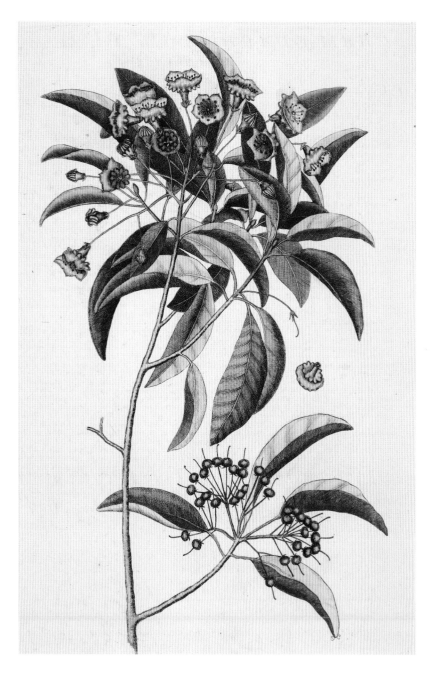

KALMIA was named after Peter Kalm, a Finnish botanist and pupil of Linnaeus who searched North America from 1748 to 1751 for plants growing sufficiently far north to endure the harsh climate of Finland and Sweden. One evergreen particularly caught his fancy: 'when other trees stand quite naked they cheer the woods with their foliage' and when in bloom 'the flowers are innumerable and sit in great bunches'. (The name calico bush came later.) Since Kalm visited both Collinson and Catesby in London before setting off for America, he already knew what kalmia looked like. He found Catesby's plant illustrations 'incomparably well represented with their natural colours on the paper', but 'not for a poor man to buy'.

Mark Catesby, *The Natural History of Carolina, Florida and the Bahama Islands*, London, 1754. 44.k.8, Vol. 2, f.98.

Kniphofia *(Red hot poker)*

THE COMMONLY cultivated red hot poker, *Kniphofia uvaria*, was introduced from the Cape in 1707, and all through the eighteenth century kniphofia were reverently treated as hothouse plants, like aloes to which they are related; but the taste for their gaudy, short-lived flowers has always fluctuated. Their name was given in honour of Professor Kniphof of Erfurt, who in 1764 published *Herbarium Vivum* in twelve folio volumes of 1200 plates, illustrated by inking actual plants and passing them through the printing press, a process known as nature printing. In a century when publishing botanical illustrations was prohibitively laborious and expensive, matched only by the enthusiasm of patrons and the experimental energy of publishers, such ventures deserved an accolade.

Pierre Joseph Redoute, *Les Liliacées*, Paris, 1802–1816. 445.h.10, Vol. 3, f.161.

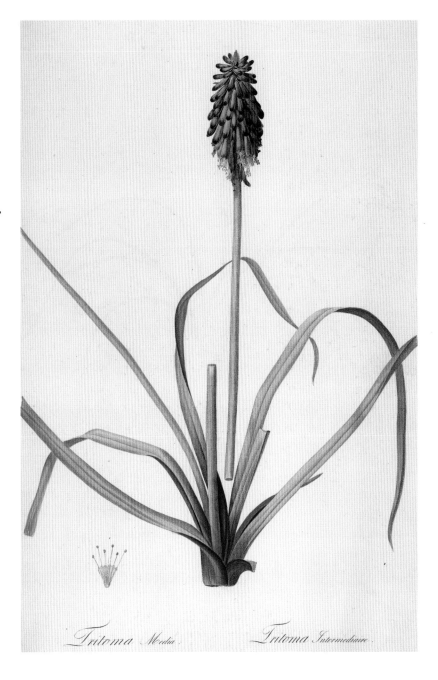

Tritoma Media. *Tritoma Intermediaire.*

Lathyrus *(Sweet pea)*

AMONG THE EXOTICS in Commelin's Amsterdam garden one came from Sicily, where wild sweet peas had remained unknown to the rest of Europe until Father Cupani described them in *Hortus Catholicus* in 1697. Their original colours consisted of purple inner petals with maroon wings and, although they were straggly little plants, none ever had a sweeter scent. Commelin, the Pope and Dr Uvedale of the grammar school at Enfield all received seeds in 1699. In 1722 when Thomas Fairchild recommended sweet peas to his customers, they were still maroon and purple, but by mid-century a variety with pink and white petals appeared, and was named 'painted lady'.

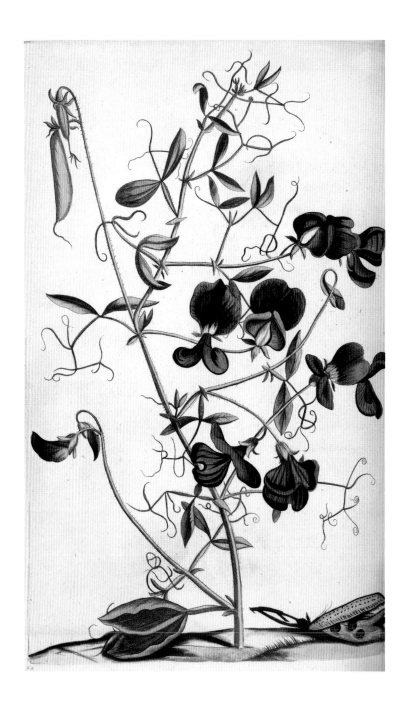

Johannes Commelin, *Horti Medici Amstelodamensis*, Amsterdam, 1697–1701. L.R.27l.c.1, Vol. 2, f.159.

Lavendula *(Lavender)*

THE SCENT OF LAVENDER, always evocative of enchanted summer days and the hum of bees, appealed strongly to the Romans. They named it after their word for washing and spread the plants across Europe because of their passion for scented baths. Traditional lavender, *Lavendula angustifolia*, submitted to this treatment but *L. stoechas* (shown right) – known as stickadove or French lavender – being less hardy, remained rare in northern Europe. Perhaps for that very reason it was considered 'much more use in physic and for pains in the head'. Also it was the only lavender species identifiable in the works of classical authors. John Sibthorp's chief aim in compiling *Flora Graeca* was to rediscover the plants mentioned in Greek herbals, but in his characteristically minimal notes he merely described it as 'widespread'.

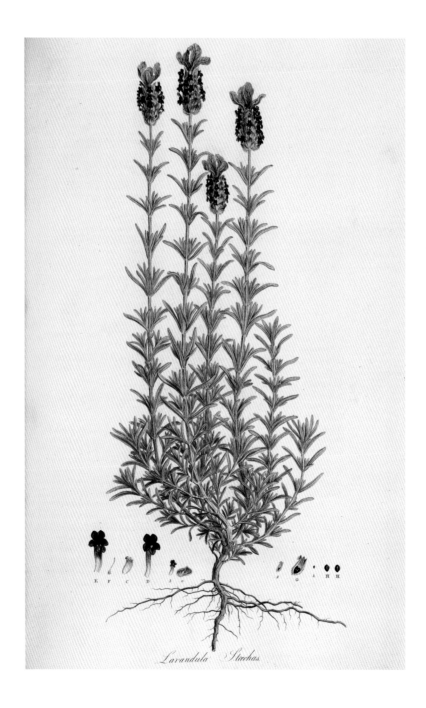

Larandula Stoechas

John Sibthorp and Ferdinand Bauer, *Flora Græca*, London, 1806–40. 453.h.6, Vol. 6, f.549.

Lilium *(Lily)*

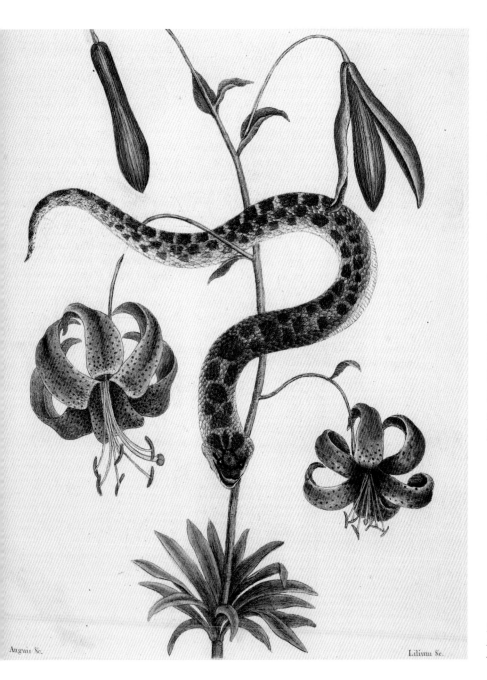

Anguis &c.

Lilium &c.

IN THIS ILLUSTRATION Catesby (for economy) melded two American lilies. The smaller and commoner *Lilium canadense*, which arrived in France in 1535, has flowers alternately up the stem and its petals are slightly recurved. The other, *L. superbum*, is gigantic and a true martagon or Turk's cap with all the flowers 'arising together from the top of the stalk' and their petals fully recurved. In 1738, as Catesby wrote, 'this elegant and stately martagon was introduced from Pennsylvania and flowered to perfection in the curious garden of my friend Peter Collinson'. The snake (was Catesby alluding to the Garden of Eden?) was 'about a foot long and very large towards the head with cheeks swelling like those of a viper'. Catesby killed it, suspecting it was venomous.

Mark Catesby, *The Natural History of Carolina, Florida and the Bahama Islands*, London, 1754. 44.k.8, Vol. 2, f.56.

Liriodendron *(Tulip tree)*

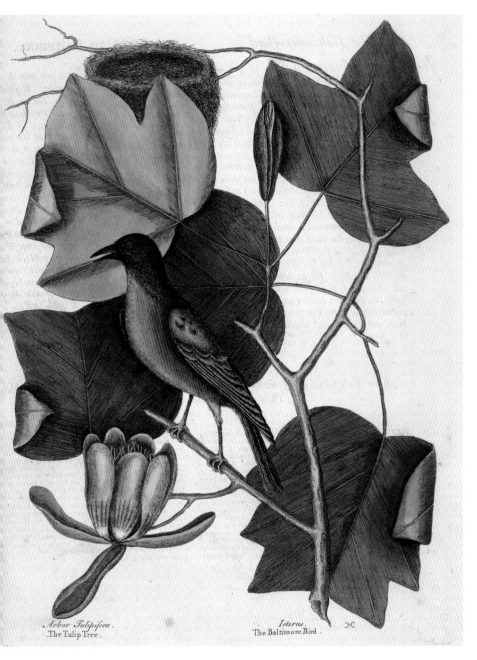

Arbor Tulipifera.
The Tulip Tree.

Icterus.
The Baltimore Bird.

TULIP TREES were introduced from America by the younger John Tradescant in 1638 and named for the shape and contrasting colours of their flowers. But few flourished until the 1730s, when John Bartram started sending boxes of plants to English collectors, including thousands of liriodendron seeds, which were mainly propagated at Lord Petre's tree nursery at Thorndon in Essex. When he died in 1743 there followed a scramble to buy his trees. The Duke of Richmond ordered '40–50 tulip trees for any price, they are not to be had anywhere else'. However, supplies of seed continued arriving and by 1768 Philip Miller could report that tulip trees had become 'common in the nurseries about London'.

Mark Catesby, *The Natural History of Carolina, Florida and the Bahama Islands*, London, 1754. 44.k.7, Vol. 1, f.48.

Magnolia

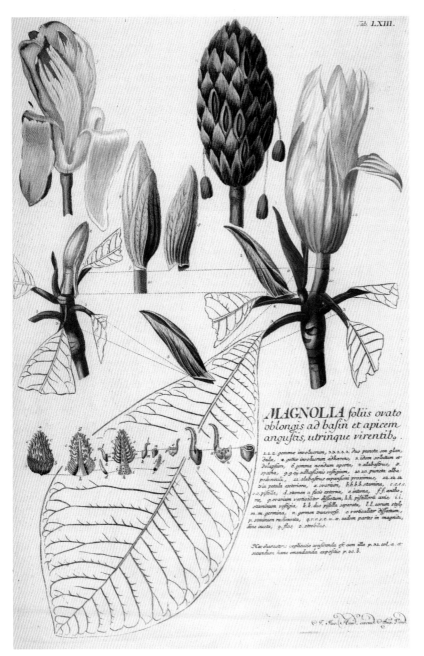

Tab. LXIII.

MAGNOLIA *foliis ovato oblongis ad basin et apicem angustis, utrinque virentib.*

BOTANICALLY magnolias are primitive, being one of the earliest flowering plants in the evolutionary scale, bearing seeds in cones. *Magnolia virginiana* was first grown by Bishop Compton in the 1680s, and 'primitive' was not the adjective used when their porcelain-white flowers unfurled. Their perfume exceeds all other magnolias but their visual impact was outshone when *M. grandiflorum* arrived. Catesby, who had already seen it in America, said it reached England shortly before 1738, when he published this illustration, dramatic against its black background. In 1739 there was a very severe winter that froze the Thames and killed many seedling magnolias, but the setback proved a temporary one.

Left: Christoph Jacob Trew and Georg Ehret, *Plantæ Selectæ*, Nuremberg, 1750–90. 460.g.15, f.62.

Opposite: Mark Catesby, *The Natural History of Carolina, Florida and the Bahama Islands*, London, 1754. 44.k.8, Vol. 2, f.61.

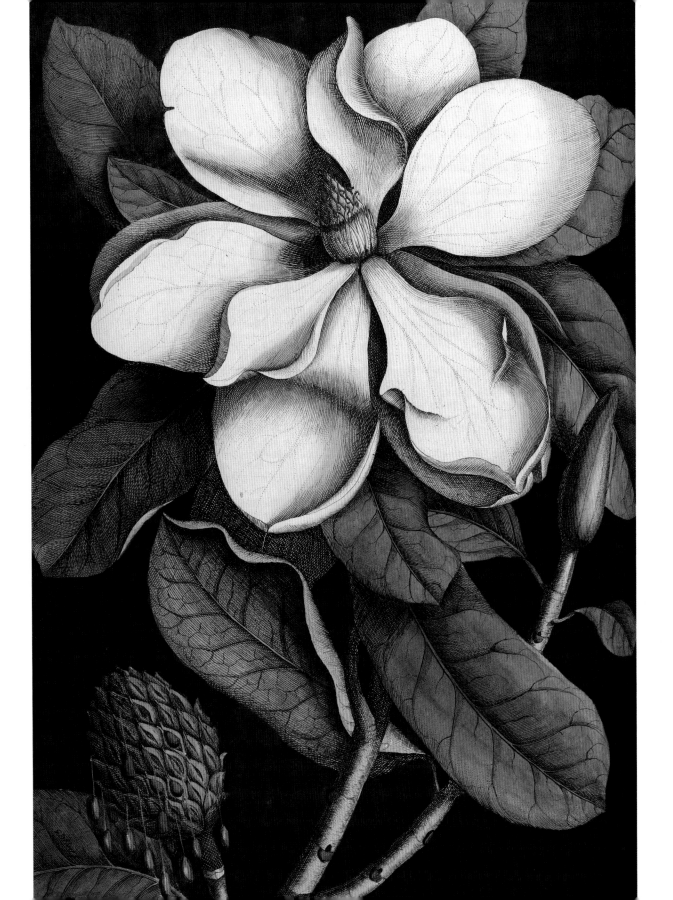

Monarda *(Bergamot)*

THE GENUS was named after the Spanish botanist Nicolas Monardes, whose description of the plants of America was translated in 1577 as 'Joyful news out of the new found world'. A 'wild mint of America' was first brought to England by the younger John Tradescant in 1638, but *Monarda didyma*, the scarlet bergamot, was collected a century later by John Bartram in Oswego on Lake Ontario – hence its name Oswego tea. Bartram sent seeds to Peter Collinson in 1744, and by 1760 there was 'plenty in Covent Garden market'. Opinions of the tea varied, but everyone praised the fragrance of the leaves, comparing it to the bergamot orange, a recent orange–lemon hybrid created in Bergamo in Italy which was rich in aromatic oil.

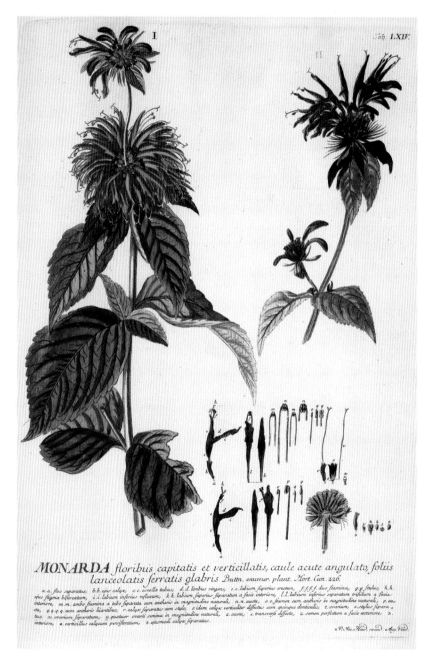

Christoph Jacob Trew and Georg Ehret, *Plantæ Selectæ*, Nuremberg, 1750–90. 36.i.10, f.64.

Narcissus *(Daffodil)*

NARCISSI are Mediterranean species and became legendary in the classical world because their bulbs are narcotic (hence their name). Even the more innocent name daffodil derived from asphodel, the plant said to grow in the Greek underworld. From the sixteenth century new species came into cultivation from Spain and Portugal – where the majority of wild narcissi originate – and from Turkey, which was the centre of bulb development until the Dutch took over. Various narcissi, especially new double forms, may be glimpsed in the paintings of Jan Brueghel (1568–1625) and his contemporaries. In the same period the collections of the German Prince Bishop of Eichstatt were displayed in *Hortus Eystettensis*, and John Parkinson listed seventy-eight varieties of narcissi. The main groups are the Ajax daffodils with long trumpets, the poeticus with short cups, the bunch-flowered tazettas, the jonquils, and the miniature species such as *Narcissus triandrus* (shown right) and *N. bulbicodium*. Many proved short lived. In the 1790s the *Botanical Magazine* illustrated various narcissi that were freshly collected from the Iberian peninsula, and the entry for *N. bulbicodium* reads 'long introduced but now scarce except in some gardens in Hampshire'.

The Botanical Magazine, W. Curtis London, 1787–1801. 678.c.1, Vols. 1–2, f.48.

Nelumbo *(Lotus)*

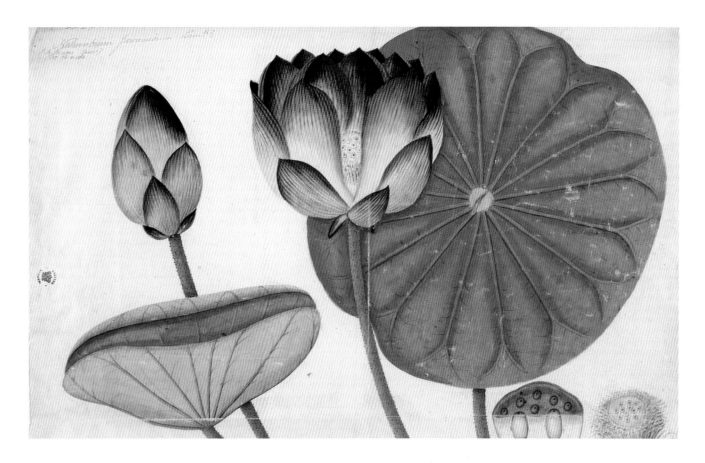

THE SACRED lotus of the East – revered in India, China and Tibet – was said to have appeared after the Great Flood, growing from the primordial mud when the world was recreated. Its magically beautiful flowers, rising above the still waters of lakes and slow-flowing rivers (and the fact that it also provides food) make splendid symbols of regeneration, both physical and spiritual. The many-petalled lotus motif may be seen from China to Egypt, and the plant became as important in Buddhist mythology as in more ancient religions. Resurrection was also an apt symbol for the career of G.E. Rumf, which he devoted to classifying the plants of Indonesia. After a series of disasters his last manuscript, illustrated by Pieter de Ruyter, triumphantly survived.

Pieter de Ruyter, *Plants of Amboina*, 1692. Add. Ms. 11027, f.77.

Nepenthes *(Pitcher plant)*

WHEN EUROPEANS encountered pitcher plants they were naturally enchanted, and nicknamed them in various languages – first the Portuguese *cannekas de mato*, then the Dutch *kannekens-kruyd* and the English monkey cups. The pre-eminent Dutch botanist of the seventeenth century, G.E. Rumf, felt that nature was playing some miraculous game. He investigated the liquid in the pitchers and realized that it was for luring and trapping insects, but he did not realize the plant also digested the creatures for nutrients. The published illustrations of Rumf's *Herbarium Amboinense* remained uncoloured, but a set of exuberant plant studies was produced by Pieter de Ruyter, a soldier turned draughtsman who joined Rumf in Amboina in 1688.

Pieter de Ruyter, Plants of Amboina, 1692.
Add. Ms. 11027, f.5.

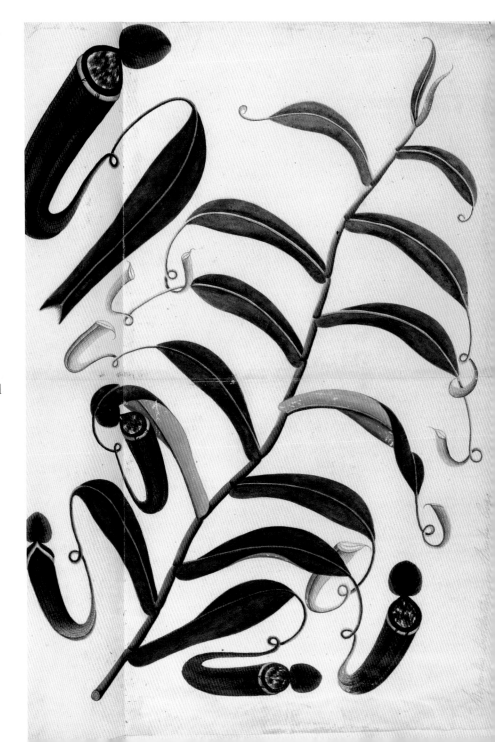

Nerine *(Guernsey lily)*

LILIO-NARCISSVS V

Japan-Lily wiht lesser Flowerr.

Schumann quod. Norimb. 35. G.D. Ehret Lond. pinx.

NERINES were among the earliest plants to arrive in Europe from South Africa. In 1634 one bloomed in the Paris garden of Jean Morin, but he claimed it came from Japan. John Evelyn and his contemporaries called them Guernsey lilies, because a ship returning from Japan was wrecked off Guernsey and the nerine bulbs, washed ashore, naturalized in the sand to the delight of the inhabitants, who commemorated their watery history in the name nerine, meaning sea nymph. Since Dutch ships returning from Japan always stopped at the Cape to revictual, this would explain how the nerines came aboard. When Francis Masson reached South Africa on the *Endeavour* in 1772 he found nerines growing wild on Table Mountain and their provenance was finally confirmed.

Christoph Jacob Trew and Georg Ehret, *Hortus nitidissimus*, Nuremberg, 1768–86 38.i.15, f.35.

Nerium *(Oleander)*

OLEANDERS are one of the most beautiful shrubs of the Mediterranean region, and from there they grow across Asia as far as Japan. But they are very poisonous. When they arrived in northern Europe they were nurtured for their pretty blooms – which earned the name rose bay – while oleander meant leaves like olives. In 1611 the elder John Tradescant received oleanders from Jean Robin, gardener to the kings of France; and there was renewed interest later in the century when a wider variety started to arrive from the East. From Ceylon Commelin gratefully received a deep red, double-flowered oleander from the 'most distinguished governor of Colombo, D. Laurens Pijl'.

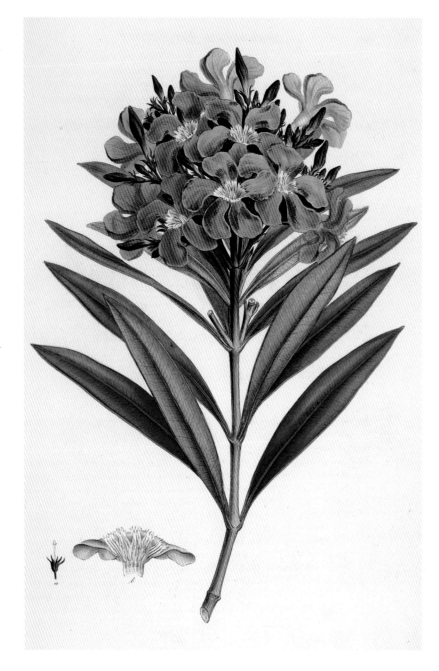

John Sibthorp and Ferdinand Bauer, *Flora Græca*, London, 1806–40. 453.h.6, Vol. 3, f.248.

Nymphaea *(Blue lotus)*

THE BLUE LOTUS of Africa and Egypt was ideal for Robert Thornton's pantheon of mystic flowers, with which he illustrated his *Temple of Flora*. The background of the painting echoed the temple theme with a mosque – looking more like Coleridge's stately pleasure dome in 'Kubla Khan' or a forerunner of the Brighton Pavilion – but certainly suggesting the areas where the blue lotus grew. The heavenly coloured petals of nymphaea were, above all, associated with the temples and tombs of ancient Egypt, the civilization that understood and revered the hallucinogenic qualities of the plant. Did Thornton with his taste for the sensational and dramatic know about this? Possibly, since he started his career in medicine, and succeeded the eminent botanist J.E. Smith as lecturer in medical botany at Guy's Hospital.

Robert John Thornton, *Temple of Flora*, London, 1799–1807. 10.Tab.40.

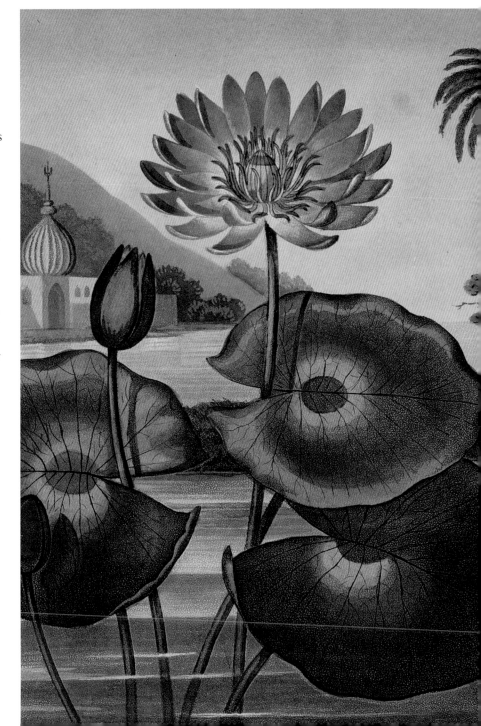

Opuntia *(Prickly pear)*

OPUNTIAS are known as prickly pears for their edible fruit, but more importantly they were a host for the cochineal insects from which a red dye was extracted. From America (where all cacti originate), they were an early example of the European propensity for transporting valuable plants worldwide –becoming the Barbary fig in North Africa and the tiger pear in South Africa and Australia. And as Indian textiles became fashionable in Europe, their production was promoted by introducing opuntias as a new source of red dye in India. This Indian natural history drawing charts the development of the cochineal insects, and the accompanying text confirms that the plants were sent from England 'as the one the louse feeds on from the West Indies'.

Wellesley Collection, *Natural History Drawings.* NHD 16, f.63.

Paeonia *(Tree peony)*

CHINESE WALLPAPERS first
introduced the fashionable world to
the charms of tree peonies, and for
years Joseph Banks 'instructed persons
trading to Canton to enquire for them'.
The first arrivals of *Paeonia moutan*
in the 1790s were pink, and whetted
appetites still more for other colours –
although it was left to Robert Fortune,
the Victorian plant hunter, to fulfil
this longing. (A passion for new types
of peony also assailed the Chinese
every spring.) Meanwhile, Joseph
Redoute produced a glorious image of
a pink tree peony in the collection at
Malmaison which, according to Aimé
Bonpland's accompanying text, had
been acquired from the East India
Company in London, 'a precious depot
of practically all the Chinese plants we
cultivate'.

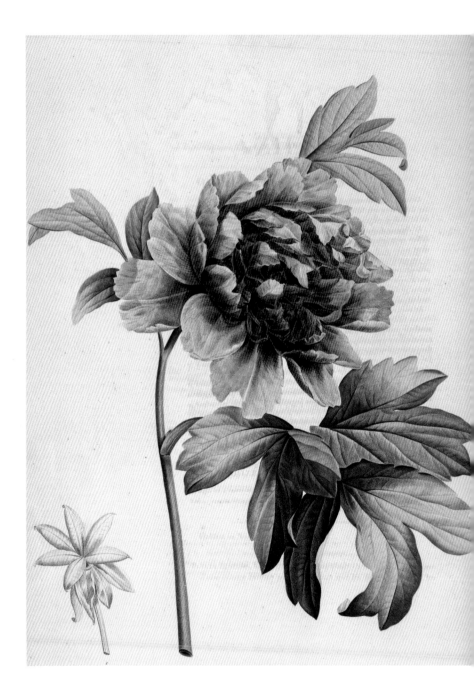

Aimé Bonpland and Pierre Joseph Redoute,
*Description des plantes rares cultivées à Malmaison
et à Navarre*, Paris, 1813. 460.g.3, f.23.

Papaver *(Poppy)*

THE POWER of opium poppies, *Papaver somniferum*, to numb pain and bring sleep has been known time out of mind. By the seventeenth century, as a result of new seeds arriving from their heartlands in Turkey, very beautiful cultivars were being introduced into European gardens and still-life paintings. A colourful range of poppies with double and serrated petals was illustrated in *Hortus Eystettensis*, the pictorial record of the plants in the Prince Bishop of Eichstatt's garden in southern Germany. The flowerbeds were created inside the walls of his fortified castle by filling the rock face with fertile soil from the river valley below (and poppy seeds like nothing better than recently disturbed soil).

Basilius Besler, *Hortus Eystettensis*, Altdorf, 1613. 10.Tab.29.

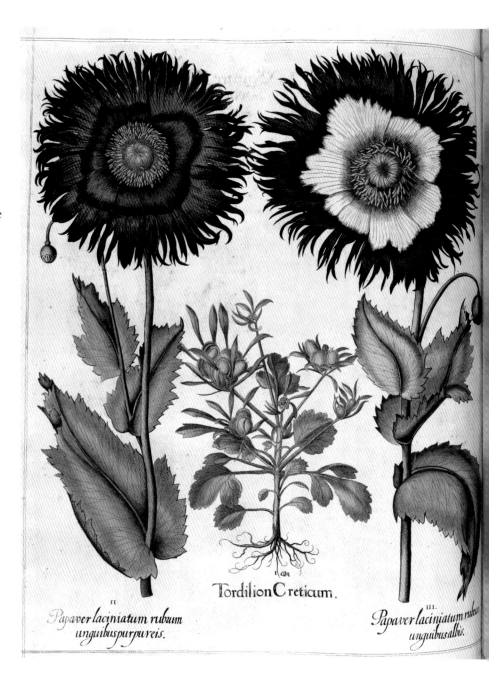

Tordilion Creticum.

Papaver laciniatum rubrum unguibuspurpureis.

Papaver laciniatum rubrum unguibusalbis.

Passiflora *(Passion flower)*

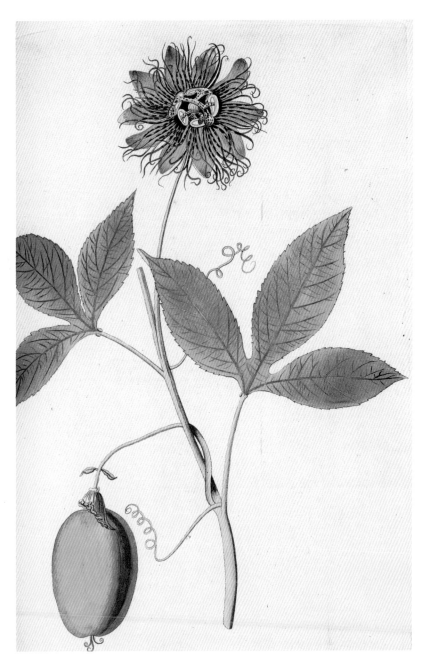

WHEN PASSION flowers were first discovered by Roman Catholic missionaries in South America, they were named according to the perceived symbols of Christ's crucifixion contained in the plant: the three stigmas representing the nails; the five anthers the wounds to his hands, feet and side; the corona of inner petals the crown of thorns; and the climbing tendrils the whips used by his tormentors. As passion flowers arrived in Protestant countries this approach was refuted but the name was retained, while increasingly beautiful species with the same curious arrangement of parts arrived during the seventeenth century. The first was *Passiflora incarnata* (shown left) from Virginia, but only the now familiar *P. caerulea* (shown opposite) proved hardy. It was first recorded growing in England during the reign of William and Mary, who introduced it among their exotic collections at Hampton Court.

Left: Nikolaus Joseph Jacquin, *Icones plantarum rariorum*, Vienna, 1781–93. 34.h.5, Vol. 1, f.187.

Opposite: *The Botanical Magazine*, W. Curtis, London, 1787–1801. 678.c.1, Vols. 1–2, f.28.

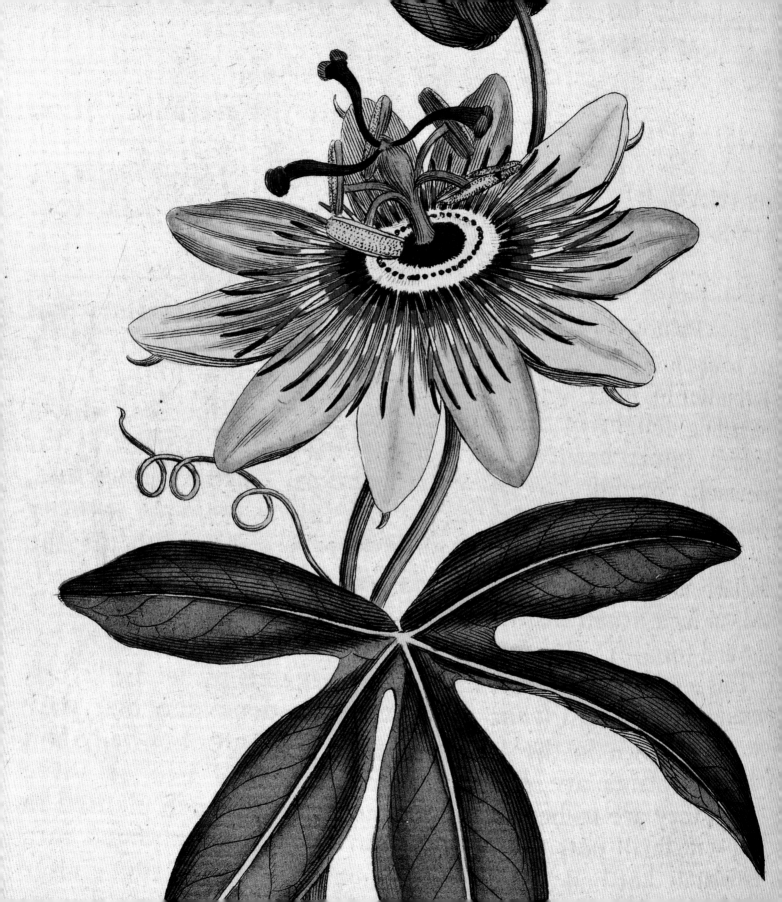

Pelargonium *(Geranium)*

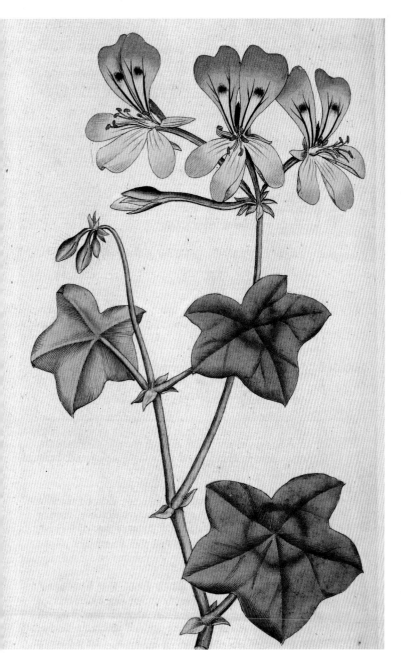

GERANIUMS (cranesbills) and pelargoniums (storksbills) are both named because their seed cases are shaped like long beaks. Botanists defined them by counting the stamens (popularly they are all called geraniums), but the plants arriving from South Africa in the eighteenth century, and needing overwintering in warmth, were pelargoniums. The first to arrive (or survive) was the ivy-leaved geranium, *Pelargonium peltatum* (shown left), one of the hardiest and easiest to propagate (grown by the Duchess of Beaufort); followed early in the eighteenth century by *P. zonale*, the ancestor of the familiar bedding geraniums. By the 1790s the *Botanical Magazine* was able to display a fine variety of new arrivals, thanks mostly to Francis Masson. Many were remarkable for the shapes and scents of their leaves – rasp-leaved, sorrel-leaved, birch-leaved – and *P. lanceolatum* (shown opposite, top left) was named 'because of its unusual spear-shaped leaves'. *P. tetragonum* (opposite, top right) had tiny leaves and square stalks, while *P. bicolor* (opposite, lower left) was first grown by John Stuart, Earl of Bute, who combined being a most unpopular prime minister with avid plantsmanship. When *P. tricolor* (opposite, lower right) was discovered in the 1790s it was 'thought to eclipse' all previous introductions.

Left: *The Botanical Magazine*, W. Curtis, London, 1787–1801. 678.c.1, Vols. 1–2, f.20.

Opposite: *The Botanical Magazine*, W. Curtis, London, 1787–1801. Clockwise from top left: 678.c.1, Vols. 1–2, f.56; 678.c.2 Vols. 3–4, f.136; 678.c.4, Vols. 7–8, f.240; 678.c.3, Vols. 5–6, f.201.

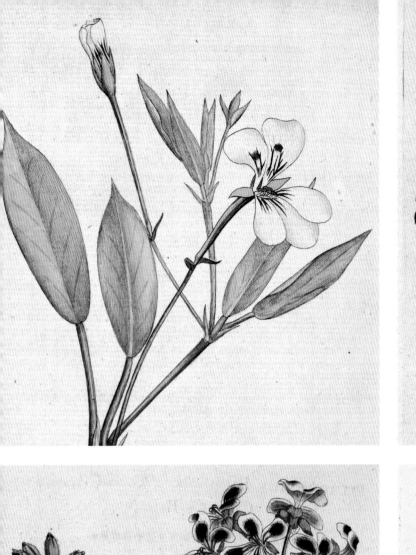
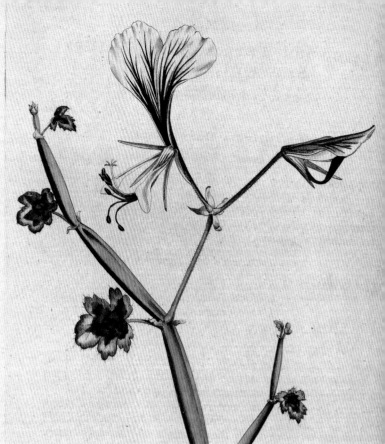
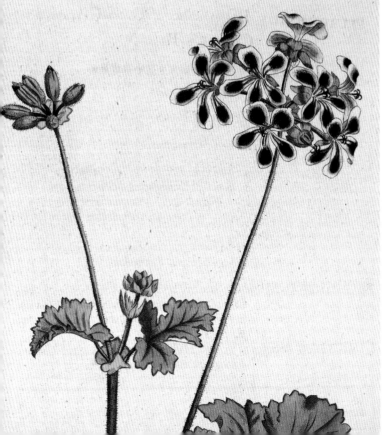
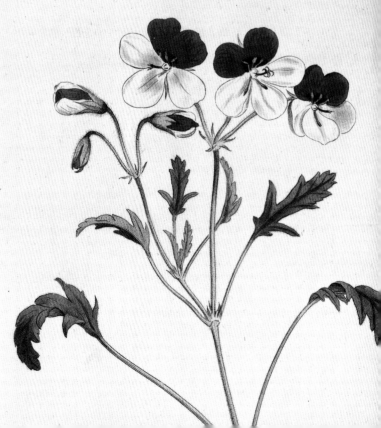

Phaius

THE FIRST PHAIUS orchid to arrive in England came on an East India Company ship from Canton, thriving in the hardened earth of its black Chinese pot. It was divided between Peter Collinson and John Fothergill, both of whom succeeded in bringing it to flower in 1778. It was a splendid sight with its caramel-coloured petals (which later earned it the name phaius, meaning swarthy in Greek) but at first it was named *Bletia tankervilleae* in honour of Lady Tankerville. She was the inspiration behind the Earl of Tankerville's fine gardens at Mt Felix overlooking the Thames, and also their involvement with the eighteenth-century gardening fraternity. The Earl's first passion was cricket, and the Tankervilles' head gardener Edward 'Lumpy' Stevens was appointed for his prowess as a fast bowler.

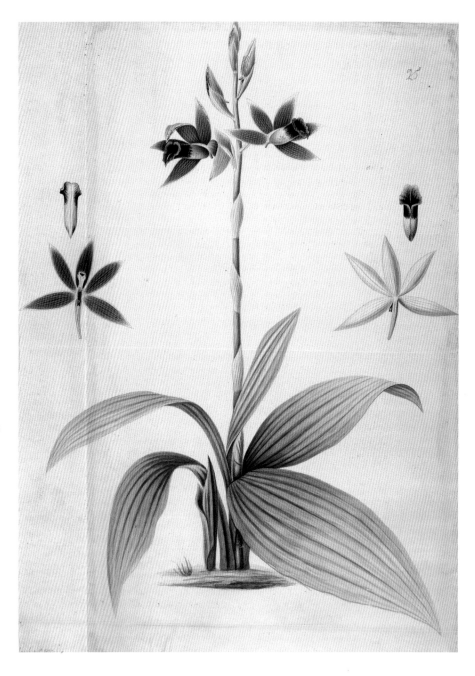

Thomas Hardwicke, *Collection of Indian Flower Paintings*. Add. Ms.11011, f.68.

Phlox

WHEN THIS MAUVE, evening-scented phlox appeared in John Martyn's *Historia Plantarum Rariorum* in 1728 it was very newly introduced from America. Martyn said it was first cultivated in Thomas Fairchild's nursery in Hoxton, where Mark Catesby lived and worked after returning from America in 1726, which suggests he introduced it. There was a rival claim from James Sherard, whose garden at Eltham in Kent was noted for its rare plants. He and his brother William Sherard (whose early botanical career was nurtured by the Duchess of Beaufort and Sir Hans Sloane) were both credited with new plant introductions. But since William Sherard arranged the sponsorship for Catesby's voyage to America, probably the brothers also received some of Catesby's phlox.

John Martyn, *Historia plantarum rariorum*, London, 1728. 456.h.13, f.10.

Plumeria *(Frangipani)*

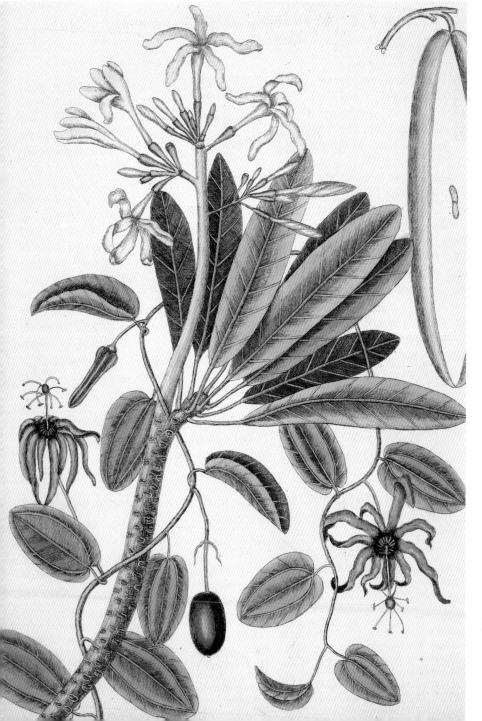

FRANGIPANI is native to tropical America, but was transported throughout the tropics, its popularity due to the sweet smell of its flowers and their waxy, white beauty. The flowers may also be pink, but pure white was more highly favoured, whether for planting in gardens and temple precincts, or worn as an ornament. The Latin name commemorated Charles Plumier, who was dispatched to the Caribbean by Louis XIV in 1689, after the King heard about Hans Sloane's plant discoveries in Jamaica (including cocoa). Catesby, following in their footsteps, visited Jamaica in 1714, and painted frangipani complete with splitting pods and entwined with *Passiflora cupaea* 'in its natural appearance as is here represented'.

Mark Catesby, *The Natural History of Carolina, Florida and the Bahama Islands*, London, 1754. 44.k.8, Vol. 2, f.93.

Prosthechea *(Cockleshell orchid)*

THE NAME COCKLESHELL orchid, given by the French botanist Charles Plumier in 1703, was inspired by the black petals of the lip, although the dangling green petals (which in most orchids would be positioned above the lip) reminded others of a squid or octopus. The watery associations were strong because these orchids were discovered on overhanging branches in the tropical swamps of Central America. The Austrian botanist Nikolaus Jacquin made his reputation when the Emperor Francis I created the Schonbrunn garden near Vienna and sent him to the West Indies to gather plants for the new hothouses. By 1756 Jacquin had established a rich collection, and hired a team of artists to portray it – including Francis and Ferdinand Bauer, one of whom captured the allure of this orchid.

Nikolaus Joseph Jacquin, *Icones plantarum rariorum*, Vienna, 1781–93. 34.h.5, Vol. 3, f.605.

Protea *(Sugar bush)*

THE *BOTANICAL MAGAZINE* for 1792 described the protea as 'a principal ornament of the Cape House at Kew', introduced by Francis Masson in 1774 after his voyage on the *Endeavour*: 'To a magnificent appearance the blossom of the protea joins a structure extremely curious and interesting. In reality it is not one flower but a number of florets within a calyx formed by numerous scales.' The protea flowering at Malmaison a few years later was even more magnificent. Its botanical features related this South African plant to several new discoveries in Australia, including banksia and grevillea – all probably evolved from ancient rainforest trees, designed for pollination by small mammals seeking nectar.

Right: Aimé Bonpland and Pierre Joseph Redoute, *Description des plantes rares cultivées à Malmaison et à Navarre*, Paris, 1813. 460.g.3, f.59.

Opposite: *The Botanical Magazine*, W. Curtis London, 1787–1801. 678.c.5, Vols. 9–10, f.346.

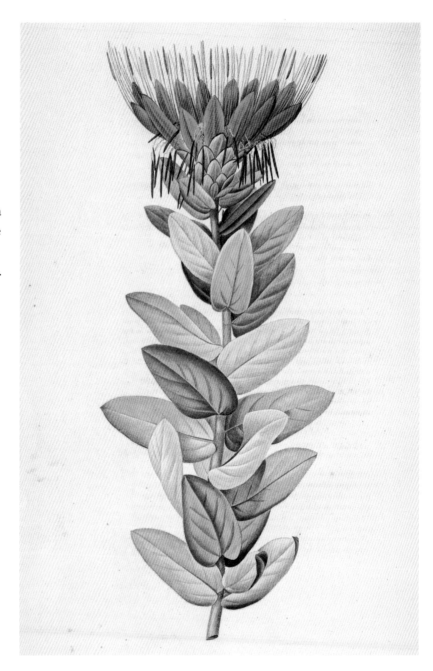

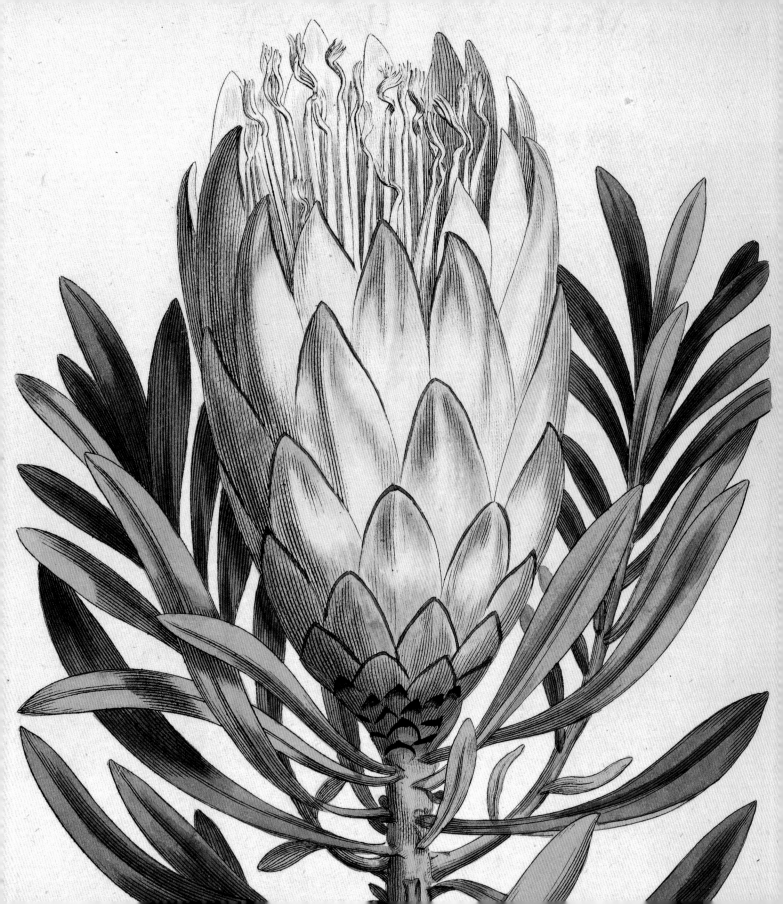

Rhododendron

THE HIMALAYAS are the heartland of rhododendrons, but their inaccessibility made the oriental species late arrivals, and the initial introductions were American plants. In 1753 Linnaeus separated evergreen rhododendrons from deciduous azaleas, but botanically they are all rhododendrons. Catesby illustrated the Virginian 'swamp honeysuckle' (an azalea), 'which will endure our climate' and which produced fragrant pink or purplish flowers. The first evergreen was *Rhododendron maximum* (not large) sent by John Bartram from Pennsylvania in 1736, with difficulty brought into flower by the Duke of Argyll at Whitton, and painted by Georg Ehret. Meanwhile, the French botanist Tournefort, on a quasi-diplomatic voyage to the Levant, discovered *R. ponticum* by the Black Sea (the ancient kingdom of Pontus). Its now ubiquitous purple blooms were first illustrated by Jacquin in 1781. Pieter de Ruyter made the first illustration of an oriental rhododendron, to be followed after another century by the *Botanical Magazine,* as the desirable plants reached Europe.

Left: Mark Catesby, *The Natural History of Carolina, Florida and the Bahama Islands*, London, 1754. 44.k.7, Vol. 1, f.57.

Opposite top left: Pieter de Ruyter, Plants of Amboina, 1692. Add. Ms. 11027, f.23.

Opposite top right: Nikolaus Joseph Jacquin, *Icones plantarum rariorum*, Vienna, 1781–93. 34.h.5, Vol. 1, f.78.

Opposite lower right: *The Botanical Magazine*, W. Curtis London, 1787–1801. 678.c.3, Vol. 5–6, f.180.

Opposite lower left: Christoph Jacob Trew and Georg Ehret, *Plantæ Selectæ*, Nuremberg, 1750–90. 36.i.10, f.66.

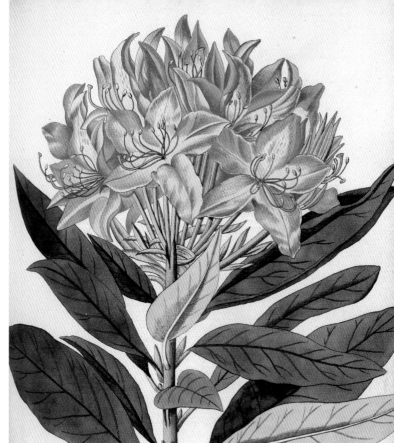
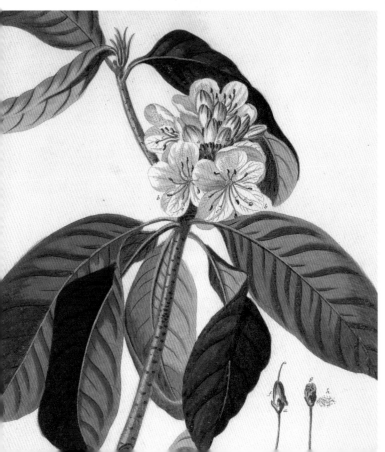
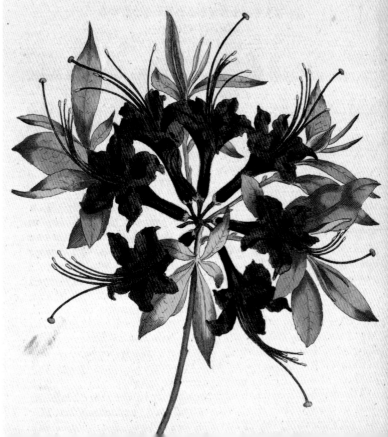

Rose

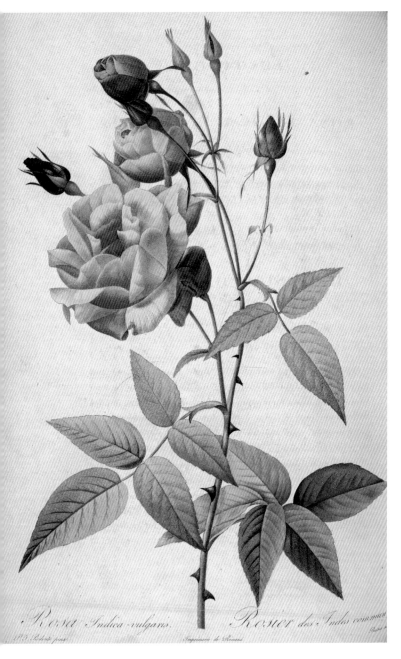

Rosa Indica vulgaris. Rosier des Indes commun.

THE INTRODUCTION of chinese roses (seen here) revolutionized rose breeding because of their prolonged flowering season – in contrast to European roses, which were as ephemeral as love poets always suggested. By 1752 Philip Miller had a pink China rose growing in the Chelsea Physic Garden and by 1790 two more were introduced: Slater's Crimson (shown opposite), named after the Director of the East India Company, who 'readily imparted them to those likely to increase them'; and Parson's Pink (shown left), later known as Old Blush China, from which 'the smallest cutting would grow'. Next, from the plant nurseries of Canton, came the tea roses, named for their subtle scent of tea leaves. By crossing these repeatedly with European roses the hybrid teas and hybrid perpetual – which are the basis of modern, repeat-flowering roses – were developed. The legendary collection of the Empress Josephine at Malmaison marked the peak of this introductory phase.

Left: Pierre Joseph Redoute, *Les Roses*, Paris, 1817–24. 450.h.22, Vol. 1, f.51.

Opposite: Pierre Joseph Redoute, *Les Roses*, Paris, 1817–24. 450.h.22, Vol. 1, f.123.

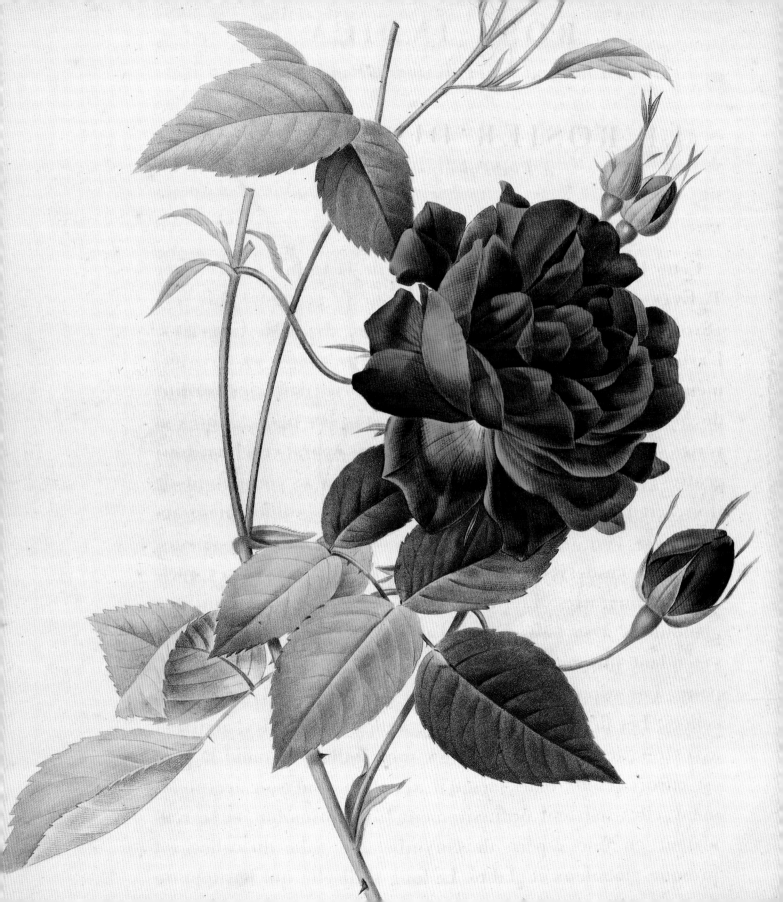

Rudbeckia *(Cone flower)*

RUDBECKIA LACINIATA, described in the seventeenth century as 'the jagged-petalled dwarf sunflower', was first introduced into France from Canada. In Paris, Vespasian Robin 'gave Mr Tradescant some roots that have increased well and thereof he hath imparted to me also' – this was according to John Parkinson, writing in *Theatrum Botanicum* in 1640. The father and son succession of Jean and Vespasian Robin as royal gardeners in France was matched by the careers of the English royal gardeners the elder and younger John Tradescants, and plants were regularly exchanged. The name Rudbeckia commemorates another father and son succession; the Rudbecks were professors of botany at Uppsala before Linnaeus, and founders of the botanic garden there.

Nikolaus Joseph Jacquin, *Icones plantarum rariorum*, Vienna, 1781–93. 34.h.5, Vol. 3, f.592.

Sarracenia

MARK CATESBY observed this curious plant as it grew in the swamps of Virginia, standing a metre tall: 'The leaves grow into a tube which opens out and arches over to protect the inside from rain which would fill and collapse it', but 'the hollow of the leaf always retains some water and seems to serve as an asylum for numerous insects, frogs and other animals'. A reasonable observation, except that the liquid Catesby observed was nectar to lure the creatures into a trap, and powerful enzymes to digest them. The red-eyed frog was appropriate food for the plant, although Catesby did not realize this as he watched it catching fireflies on hot nights, and tried tempting it with the glowing embers knocked from his pipe.

Mark Catesby, *The Natural History of Carolina, Florida and the Bahama Islands*, London, 1754. 44.k.8, Vol. 2, f.69.

Selenicereus *(Night-flowering cactus)*

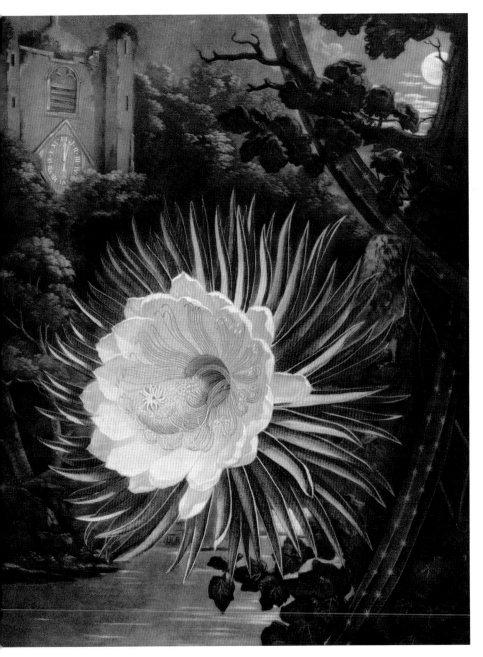

THE STUNNING NIGHT – flowering cactus from Jamaica, first described around 1700, opened only in the dark, for the briefest necessary time to be pollinated by a moth, and was consequently hardly ever seen. To portray this phenomenon in the *Temple of Flora*, Thornton placed a church tower in the background with the hands of the clock just passing midnight and 'the moonlight playing on the dimpled water'. Climbing up the incongruous oak and ivy, the cactus spread its petals and stamens like the fires of a comet around the star-like female stigma. Thornton's scene shared the romance and melodrama of an opera – indeed Mozart's *Magic Flute* was composed in 1791, and the cactus became known as the Queen of the Night.

Robert John Thornton, *Temple of Flora*, London, 1799–1807. 10.Tab.40.

Sprekelia *(Jacobean lily)*

JEAN ROBIN, GARDENER to Henry IV of France at the Louvre, was at the nexus of early seventeenth-century plantsmanship, offering rarities and advice to foreign visitors, including the elder John Tradescant when he visited Paris. Robin was also crucial in establishing the royal tradition of collecting exotics and hiring botanical illustrators to commemorate them. Many of the illustrations appear crude in comparison with eighteenth-century botanical art, but the sprekelia is magnificent. Native to Mexico, and introduced via Spain, its name Jacobean lily commemorated St James of Compostella, patron of pilgrims and the Spanish crusades, whose emblems were the pilgrim's shell and the crimson sword, which sprekelia seemed to resemble.

Pierre Vallet, *Velins du Roi*, Paris, 1608. 35.g.3, f.16.

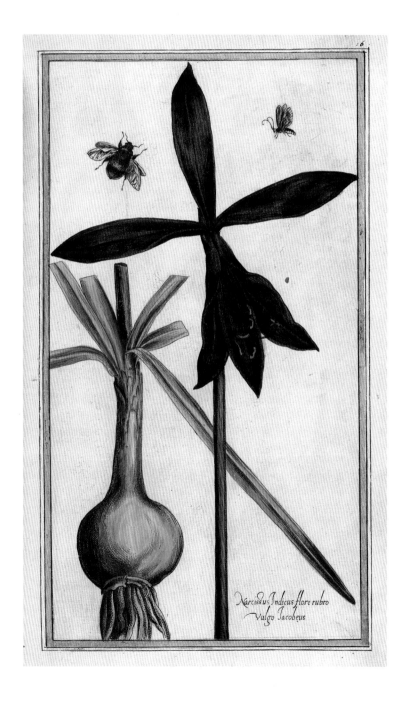

131

Stapelia

OF ALL THE SOUTH AFRICAN plants Francis Masson successfully nurtured and dispatched to Kew, he devoted his monograph to stapelia, presumably the plants that fascinated him most. In *Stapeliae Novae* he described and depicted forty different species with loving attention to their individual details and precise notes on habit and habitat. Masson wrote with seeming modesty that his illustrations 'have little to boast in point of art' – but might represent the actual appearance better than figures made from hothouse plants – possibly a sideswipe at stay-at-home collectors and artists. As if in response, Thornton devoted a rather ugly plate to stapelia in the *Temple of Flora*, including the eggs and hatching grubs deposited by pollinating flies.

Stapelia grandiflora

Francis Masson, *Stapeliæ novæ*, London, 1796. 453.f.17, f.11.

Strelitzia *(Bird of paradise or crane flower)*

STRELITZIA WAS introduced from South Africa by Francis Masson in 1774, after his voyage aboard Captain Cook's *Endeavour*. When it unveiled its astonishing flower in the royal hothouse at Kew, Joseph Banks named it in honour of Queen Charlotte, wife of his patron George III, who was a princess of Mecklenburg-Strelitz. The *Botanical Magazine* for 1791 said it remained very scarce and expensive, and seldom flowered in a pot unless its roots escaped into the 'rotting tan' of the hothouse beds. The bird associations of its popular names were apt because the flower is adapted for pollination by sunbirds, which land on the horizontal spathe, attracted by the bright colours and the promise of nectar.

Pierre Joseph Redoute, *Les Liliacées*, Paris, 1802–16, 445.h.9, Vol. 2, f.77.

Teleopea *(Waratah)*

THE WARATAH was first described by Joseph Banks in his Botany Bay collections, and later became an emblematic flower of New South Wales. Alongside Sowerby's illustration, which was 6 inches (15 cm) across and lifesize, J.E. Smith wrote 'the most magnificent plant which the prolific soil of New Holland affords … it is a favourite with the natives upon account of a rich, honeyed juice which they sip from its flowers'. Regretfully he added that 'seeds brought to this country have never vegetated', although Lady Clifford 'received living plants from Sydney Cove which have not yet flowered'. Sowerby had to create his illustration from dried specimens and drawings sent from Australia by John White, and the result proves the skill of both men.

James Edward Smith and James Sowerby, *A Specimen of the Botany of New Holland*, London, 1793. 443.g.29, Plate VII.

Tropaeolum *(Nasturtium or Indian cress)*

TROPAEOLUM is native to Central and South America, and the smaller *Tropaeolum minus* first reached Spain in the sixteenth century. In France it was cultivated by Jean Robin, the king's gardener, who sent seeds to England. John Parkinson called it yellow larkspur, 'the prettiest flower in the garden … and being placed with gillyflowers makes a delicate tussie mussie or nosegay both for sight and scent'. But mostly it was valued as a nourishing salad herb (confusingly, *nasturtium* is the Latin name for water cress), and John Evelyn recommended the powdered seeds for mustard. The larger *T. majus* superseded the smaller when it was introduced in 1684, and in the mid-eighteenth century double forms from Italy aroused fresh interest.

The Botanical Magazine, W. Curtis London, 1787–1801. 678.c.1, Vols. 1–2, f.23.

Tulip

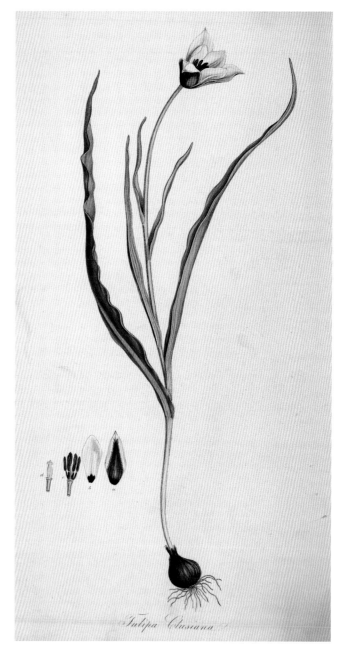

THERE ARE wild tulips, like *Tulipa sylvestris* (shown left), that are native to Europe, but the ancestors of the garden cultivars were oriental species originally brought along the silk routes from Central Asia. They reached Austria in the mid-sixteenth century from Ottoman Turkey, developing such variety that they provoked collectors' mania – and in Holland even financial speculation, leading to an inevitable market crash in 1637. In 1787 John Sibthorp discovered *T. clusiana* (shown right), one of the ancestral tulips, growing wild in Turkey. It was appropriately named after Clusius, who nurtured the first arrivals in Europe. In eighteenth-century Turkey, tulip festivals were held by candlelight, to the sound of caged nightingales singing. The petals of these Ottoman tulips were elongated ribbons of colour with pointed tips, a characteristic derived from *T. acuminata* (shown opposite), a strange and beautiful flower which entered the collection of the Empress Josephine and was illustrated by Redoute.

Above: Pierre Joseph Redoute, *Les Liliacées*, Paris, 1802–16. 445.h.10, Vol. 3, f.165.

Right: John Sibthorp and Ferdinand Bauer, *Flora Græca*, London, 1806–1840. 453.h.4, Vol. 4, f.329.

Opposite: Pierre Joseph Redoute, *Les Liliacées*, Paris, 1802–16. 445.h.10, Vol. 8, f.455.

Vanda

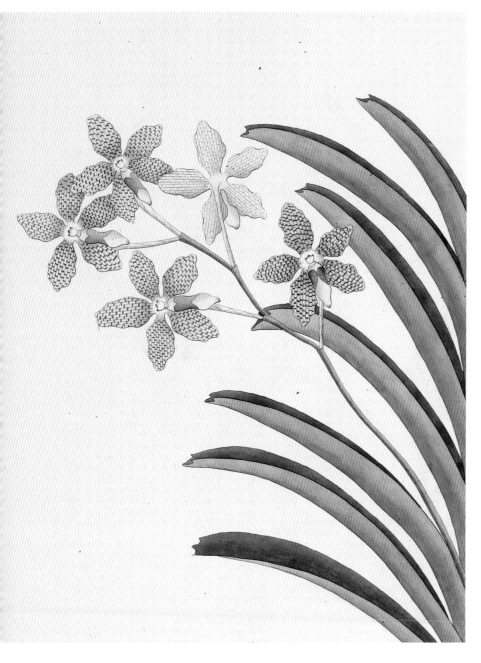

THE VANDA ORCHIDS of India and Malaysia are related to the now ubiquitous phalaenopsis, also known as moth orchids. Even more startling than their beauty was their habit of growing in massive bunches on the branches and trunks of trees. William Roxburgh described vanda as 'a very beautiful perennial parasite', but since the orchid does not harm the tree the relationship is an epiphytic one. This illustration of *Vanda oronbunglia* by an Indian artist (probably in the 1770s) was among the abundant supply, finally totalling over two thousand, commissioned by Roxburgh and sent to the directors of the East India Company to provide them with an idea of the botanical treasures of India. From these Joseph Banks selected about three hundred for publication in *Plants of the Coast of Coromandel*.

William Roxburgh, *Plants of the Coast of Coromandel*, London, 1795–1819. 10.Tab.34, Vol. 1, f.42.

Zantedeschia *(Arum lily, calla lily)*

ARUM LILIES were among the South African plants treasured by Jan Commelin in Amsterdam and by the Duchess of Beaufort in Chelsea – whereas in the Transvaal they grew in such profusion in damp places that they were called pig lilies (perhaps the smell characteristic of arums that are pollinated by flies contributed). Their Latin name was given in honour of an Italian botanist, Giovanni Zantedeschi. In America a similar wild arum with a white spathe and characteristic protruding spadix, and a preference for swampy places, was called *Calla palustris* – hence the confusion created by florists selling calla lilies, which are in fact zantedeschias that have been developed in various rich colours.

Johannes Commelin, *Horti Medici Amstelodamensis*, Amsterdam, 1697–1701.
L.R.271.c.1, Vol.1, f.95.

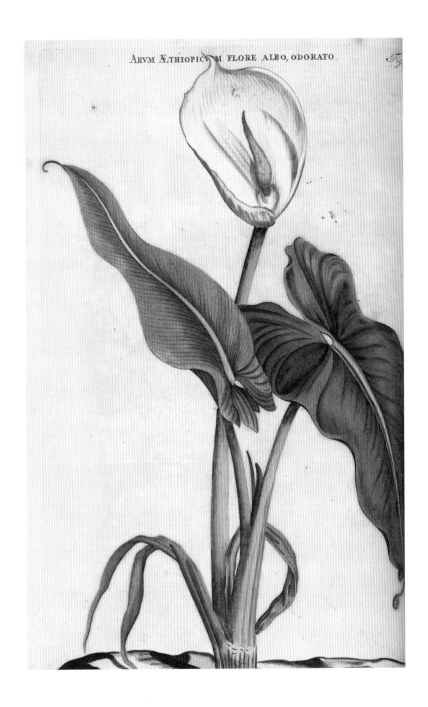

ARVM ÆTHIOPICVM FLORE ALBO, ODORATO.

Zinnia

ZINNIAS were cultivated by the Aztecs of Mexico, who also developed dahlias and tagetes. In 1753 the first zinnias to arrive in Europe were *Zinnia tenuiflora*, which produce a profusion of delicate red flowers. Linnaeus named them after a German botanist, Johann Zinn (while dahlias were named after the Swedish botanist Anders Dahl, who regarded them as a promising new vegetable). Seeds of the larger flowered Z. *elegans*, the ancestor of modern zinnias, were sent to England by the British Ambassador soon after they arrived in Spain. He also sent dahlias, then known as *cocoxochitl*. Of the two new introductions zinnias proved far easier to cultivate and bring into flower.

Right and opposite: Nikolaus Joseph Jacquin, *Icones plantarum rariorum*, Vienna, 1781–93. 34.h.5, Vol. 3, f.590 and f.589.

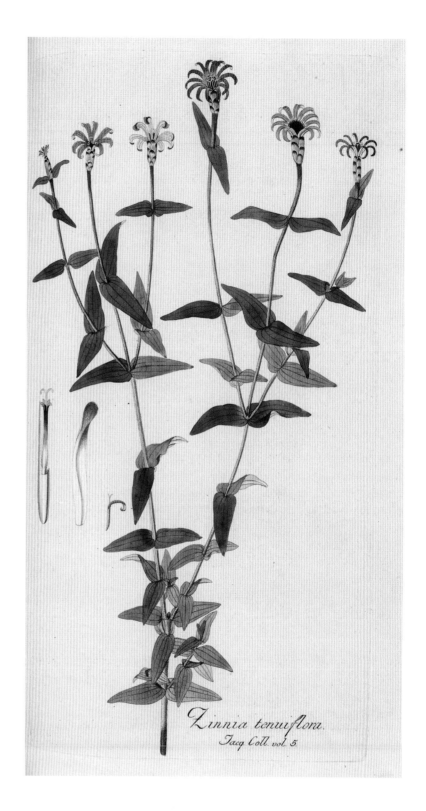

Zinnia tenuiflora.
Jacq. Coll. vol. 5.

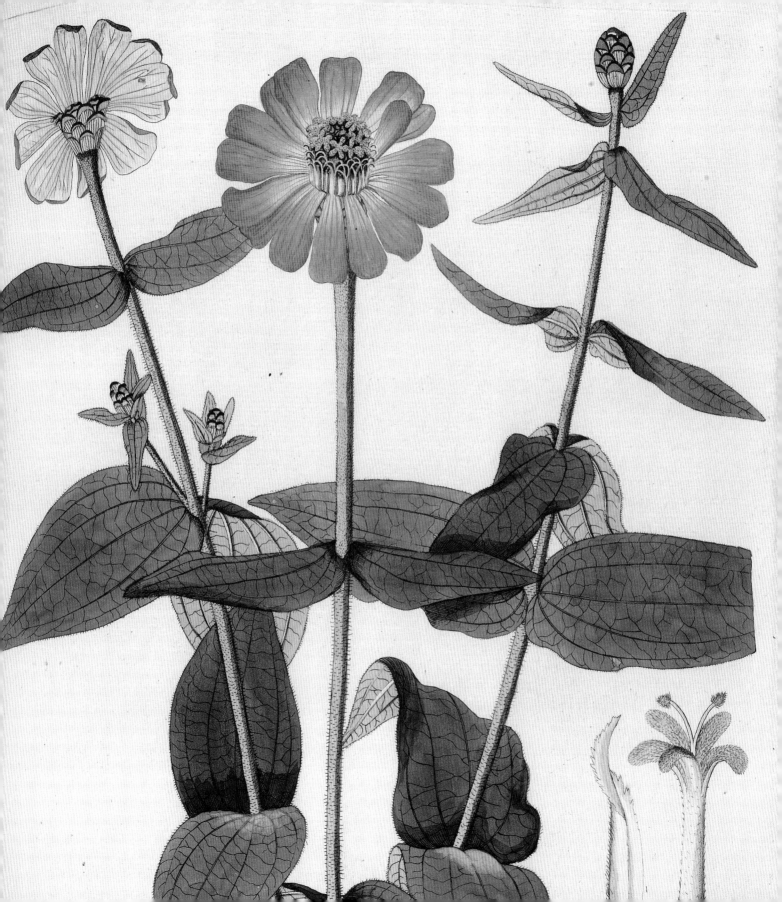

Index

Further Reading

Blunt W. and Stearn W., *The Art of Botanical Illustration* (London 1950, new edition 1994)

Chambers D., *The Planters of the English Landscape Garden* (New Haven & London, 1993)

Coates A., *The Quest for Plants; A History of Horticultural Explorers* (London, 1969)

Campbell-Culver M., *The Origin of Plants* (London, 2001)

Desmond R., *The History of the Royal Botanic Gardens, Kew* (London, 1995, new edition 2010)

Hobhouse P., *Plants in Garden History* (London, 2004)

Laird M., *The Flowering of the Landscape Garden* (Philadelphia, 1999)

Le Rougetel H., *The Chelsea Gardener, Philip Miller 1691–1771* (London, 1990)

Rix M., *The Art of Botanical Illustration* (London, 1981, new edition 1989)

Wulf A., *The Brother Gardeners, Botany Empire and the Birth of an Obsession* (London, 2008)